THE COUNTERFEIT PRINCE OF OLD TEXAS

THE COUNTERFEIT PRINCE

OF OLD

TEXAS

SWINDLING SLAVER MONROE EDWARDS

LORA-MARIE BERNARD

THE
History
PRESS

Published by The History Press
Charleston, SC
www.historypress.net

Unless otherwise cited, images are courtesy of Colonel Frank Triplett, *History, Romance and Philosophy of Great American Crimes and Criminals*, in the public domain.

First published 2017

Manufactured in the United States

ISBN 9781467117876

Library of Congress Control Number: 2016945911

Notice: The information in this book is true and complete to the best of our knowledge. It is offered without guarantee on the part of the author or The History Press. The author and The History Press disclaim all liability in connection with the use of this book.

To Michael Bailey and my friends at the Brazoria County Historical Museum for sharing the great stories about long-forgotten Texans who built, squandered, rebuilt and loved this great state and its coastal prairies.

Thank you for letting me be part of your world. You'll always be part of mine.

CONTENTS

PREFACE

.

Good criminals make the most fascinating stories.

Perhaps it's the secret wish that we could be so bad, or maybe it's just the reassurance that we are morally superior.

I never wanted to write about crooks or drugs or the nasty elements, as I saw them. My goal was to write about a cadre called the beautiful people. But life has a strange way of sneaking up on you and turning your path when you aren't looking.

By the time I became a crime writer, I was not looking forward to it, and when I left, I was ready. Never, I thought, would I return to that sordid genre.

Alas, crime writing has dragged me back to its den. I wasn't looking for Monroe Edwards, and when I found him, I was irritated that I couldn't throw him away. Reporters do that. We find a community story, hear it, transform every single real person into a character and then determine if those characters are worth our effort. If they don't pass muster, they get thrown away. Monroe refused to let me throw him away.

Michael Bailey began the madness. While working on my first book, *Lower Brazos River Canals* (Arcadia Publishing, 2014), he began babbling about a slave smuggler and forger and a plantation warehouse. He threw in big Texas characters and events like William B. Travis and the Battle of Anahuac. It was all very confusing, and I wanted him to stop talking. None of this had anything to do with the river. He'd hand me a photo of the river and then, somehow, turn the whole day back into stories about Monroe Edwards.

PREFACE

Worn down, I agreed to study Chenango Plantation and look over the museum's overstuffed, unorganized folder tagged "Monroe Edwards." Inside this collection of news articles, trial transcripts and handwritten notes, I found a character unlike most in Texas. Hollywood and politics have created a picture of Texas that instills an emboldened pride, a reverence for its revolutionary rebels and a solemn pledge to its lost nationhood. People like Monroe Edwards are not part of that narrative. Perusing his time as a prisoner in the Battle of Anahuac, I became intrigued by the path he chose. Where Travis is part of the average Texas school child's history lesson, Monroe Edwards isn't part of the curriculum. More amazingly, Monroe was partly raised by one of Texas's greatest heroes, James Morgan. That was a breadcrumb.

I had to follow the story for a few spellbinding hours. I decided to put this Monroe character away, finish my first book and see if he stuck with me. Was he a big enough character to be worth the effort?

When Monroe died in 1847, he was considered the most celebrated American forger until the turn of the century. He was memorialized in penny dreadfuls and long essays from prison officials and writers alike. The life of Monroe Edwards was a hot-boiled pot of fact and fiction. The fiction was easy to find. The fact was going to be harder. I let the research marinate until his story started to percolate. In the end, I agreed with Bailey. I was off to comb the life of another crook. "Crime Reporter Chapter Deux" was about to start.

Historical documents proved to be few but relatively easy to find. Reading them was the challenge. The language of the day was stilted and flamboyant at the same time. Deciphering what was being said was one thing. Translating it to today's terms was another. Never mind that the documents were hard to read. Somewhere along the way, the penchant for squeezing long reams of paper from the 1800s onto today's standard letter-sized sheet became the norm. Words went from fifteen-point handwritten flourishes to three-point tiny scribbles in the blink of an eye.

Monroe's real life eventually began to bubble out of the reams, penny dreadfuls and newspaper articles. In most narrative-driven accounts, he is painted as a deceitful crook who deserved what he got. The last hours of his life were lonely, painful and just plain sad. Good comeuppance is the general message. But the truth of his life is more complex. In between the swashbuckling retellings emerges a common tale I'd seen as a crime reporter covering the boys who joined drug gangs. At a crucial age, he was sent away from his home in Kentucky to live in New Orleans. By the time he returned

to his family in Texas, his father soon died. Left alone, he began to make the choices that turned him into the scoundrel he would become. Underneath the criminal mastermind lies a complex man who captured the love of a slave girl, the attention of a nation and the trust of British aristocracy.

By the time, I'd finished my research, I discovered the secret to his story. The American public found him fascinating for more than half a century because he was deeper than his image. His life was large. His schemes were grand. His style was fashionable. His personality was charismatic. His lies sounded truthful. The nation wanted to give him a second chance. America celebrated his masterful, extraordinary life.

All he wanted to do was find the life his father wanted the family to have.

ACKNOWLEDGEMENTS

The incredible assistance from my friends on the second floor at the Brazoria County Historical Museum was, as always, my first blessing. Michael Bailey's fascination with Monroe Edwards couldn't help but end up sprinkled on me at some point.

Thanks to The History Press and my editors, Christen Thompson and Ben Gibson, for being so easy and comfortable to work with.

To my lifelong companion, Bobby Gervais, whose best gift was to leave me alone while I got lost in the criminal world of forgery, the dark cruelty of slave smuggling and the legends of the great state of Texas, I thank you. Always and forever, nothing I do means anything without you.

"THE VENGEFUL FOE HAS RAISED HIS HAND"

The vengeful foe has raised his hand
To sap my ardent years;
Fiendlike puts forth his blood-red hand,
Spreads his dark pall, intent to fling
A gloom around each lovely thing,
And turn its smiles to tears.

The bow is bent, the bolt has sped—for me
The world is fair in vain,
Spring comes and goes and I am free,
But change nor season time can move
My forever leaf of life restore—
It cannot be again.

A wreck of manhood, oppressed, o'ertried,
I stand amid a waste;
My source of joy has long been dried,
And the false friend, to whose ear
My every word was once so dear,
Now passes me by in haste.

And thus it is the world to prove;
How soon the spell has fled!

"The Vengeful Foe Has Raised His Hand"

How falsehood follows fast on love,
Treachery on trust, and guile on truth,
Until the heart so full of youth
Is wearied, waste and dead.

I once reared high a brow of pride.
Who shall gainsay my right?
And many a blushing beauty sighed
To the enamored speech that erst
With lover's warmth from my lips that burst
The zealous rapture bright.

In days gone by, with heart in hand,
Who happier was than I?
Blithe as the proudest he in all the land;
But as last the Demon, slander, came,
And "armed to the teeth" his only aim,
With infamy my name to die.

The tale goes forth upon the winds,
Harkened to by all,
And with its withering venom stings;
No friendly hand is reared on high
To contradict the blasting lie,
And I am doomed to fall.

—Monroe Edwards, New York Tombs, 1842

1

SWINDLED

Monroe Edwards chewed his fingers like a dog eats its favorite bone. His fingers, stuck beneath his chin, would rise to his mouth, where his teeth would bite them over and over again.

His delirious and sweating body lay prostrate on a cot in the Sing Sing prison hospital. He barely resembled the man who had been—for a time—New York's favorite prisoner and the nation's celebrated forger. Women with giddy crushes would visit him. They'd sneak saws to him so he could cut through iron. They wished for this dashing gentleman to escape. Men would visit the prison just to see him work as a convict in the shops. Monroe Edwards was an iconic figure. This was the international forger who had created a wealthy slave-smuggling market, escaped a hanging death in Texas and almost swindled America's first New York investment bank.

Now, on this gloomy night, he was nothing more than a repeatedly beaten prisoner in Sing Sing who begged to die. The year was 1847. It was January 27, a Thursday night. The dead of winter lingered just outside.

For hours upon hours Monroe chewed the fingers that had made him famous. In the days before he lost his mind, he was a mere shell. Once, America had described him as a man who led a celebrated and extraordinary life. That wasn't who he was now. His curly locks were shaved to the skull. His luxurious whiskers were cut away. He had a dark frown over his forehead. His cheeks were pale, and his lips were compressed with remorse, rage and despair.

"Am I dead?" he asked the nurses over and over again. When they would reply, once again, that he was not, he would start the circular argument

again. He knew he had to be, and they would not tell him so. To prove them wrong, he would chew his fingers until they were raw.

"But I am," he would tell the nurses as he gnawed and tore at his flesh. "I am. I feel nothing."

Only a dead man cannot feel his fingers, he cried.

From the minute Pastor John Luckey met Monroe, he was struck by his charisma and manners. Luckey, with the prison warden, arrived in 1842 to prepare the forger for his transfer to Sing Sing. Monroe was self-assured, the pastor said, and completely confident. When the two met, Monroe had just been convicted of swindling and forging the Alexander brothers out of $40,000, or more than $600,000 in today's money. In the original scheme, he attempted to steal more before it backfired. His swagger as he heard his ten-year sentence astounded the audience.

Four years earlier, Monroe had taken the Northeast coast by storm. By the time he stood trial, he had captivated colonists, settlers, pioneers and citizens from the East Coast to Minnesota. The western regions had newspapers reprint the accounts from journalists who covered the spectacle. The entire episode was so salacious that one of Monroe's lawyers ended up in a duel with a journalist to defend his client's good name.

The scoundrel had the good looks that God grants to a few chosen individuals in every generation. His carried the veneer of a gentleman. He behaved like a wealthy statesman. His clothes were pressed each day before trial as though he were going to a stately ball. Women swarmed the courtroom to get a glimpse of him. Some fainted and swooned from the stifling crowd that left little room to breathe.

His trial captured the imagination of commonplace citizens, and the courtroom was filled with the most prized of New York's bluebloods.

In the days before he was sent to Sing Sing, he still had his special southern country sparkle. He decorated his cell like a parlor, where he hosted lively meetings with courtesans. He wore a morning gown. His black whiskers were perfectly groomed. He had the air and manners of a prince receiving the honors of subjects. When Pastor Luckey arrived, he wasn't surprised at the scene. He had seen it before. He was looking at a man who had no intention of repenting anything. Monroe was too popular for it.

Luckey said, "It has too frequently the tendency to create the desire in the minds of less notorious criminals to become 'men of mark' also; and hence they sometimes say, as one of them did to me a short time since, 'Had I been as great and famous a criminal as…I would have equal attention paid to me by ministers, and other distinguished visitors.'"

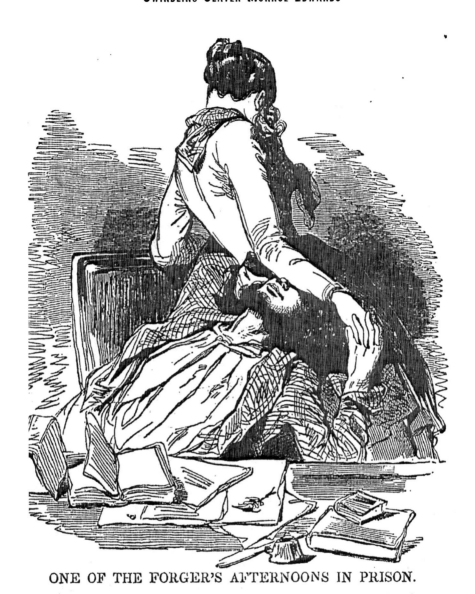

ONE OF THE FORGER'S AFTERNOONS IN PRISON.

Luckey speculated that Monroe would continue his con games even behind the rough walls of Sing Sing: "I had no reply for this legitimate inference, drawn from the too common practice. For myself, I can say, they are not the men I hasten to seek out as needy and hopeful subjects for moral and religious effort; my mission is first to the ignorant and friendless."

The pastor never did reach out to Monroe after that first meeting in the Tombs. He waited for Monroe to come to him. Every Sunday from the pulpit, the pastor told the convict congregation that he would visit anyone in his room if asked. Monroe never asked. Instead, the pastor saw Monroe making common and predictable decisions. Monroe wanted to be as celebrated in prison as he was in free society. It didn't matter where he was; he was going to have the effects of culture:

> *There are always in the prison certain characters who have, in some way, made themselves notorious, and great solicitude is generally manifested by visitors to see them, or have them pointed out. The gratification of this desire on the part of officers I have always considered wrong, from the fact, that one class of these characters become inflated with pride by early and marked attention, while another class recoil with vexation from the annoyance it causes them to be "the observed of all observers."*

Monroe Edwards works as a convict at Sing Sing.

Monroe was assigned to the shoe shop, and soon he was moved to the carpet shop, where he began quietly networking and noting people's positions. Around this time, the pastor received a series of letters that Monroe was writing. The pastor opened them and began to read them, since that was part of his job.

Monroe was imploring several high-ranking politicians to help his dire case. After all, he came from Texas, where his rich plantations were bursting with

Monroe's mother reads a letter from her son.

money to pay them for their kind regards. These letters went unanswered. Soon after, Luckey saw the bottom rise. Monroe realized he was not just a convicted criminal. He was officially shuttered. Only his mother wrote to him, and she didn't have good news.

Her letters revealed that Monroe might have been a calculated crook with one redeeming quality: he cared for and loved his mother. During his final years, he received two letters. Both were from her. She was on the family's property on the Galveston mainland in Texas; she'd mortgaged it to pay for his expensive New York trial. Now, Edwards Point, and perhaps even his brother-in-law's property, was in danger of foreclosure. The matter weighed on her, and although Monroe was in prison, she implored him to help her. Luckey saw this troublesome situation unfold between them over time. Luckey knew the prisoner was grappling with the demise of his family's fortune:

> *I knew also that he had read a letter from her, which passed through my hands, begging his assistance to save her property; and the fact that her urgent solicitations were not responded to, was conclusive evidence to my mind, that by far the larger portion of his wide spread and well-stocked plantations were "the baseless fabric of a vision."*

He did not write back. Instead, he wrote letters to his lawyer and power of attorney, John Crittenden. Monroe begged him for money to save the family. He wrote to others. No one answered his plea.

On Monroe's death bed, Luckey sat with him as he descended into the throes of a listless insanity. The thoughts of his abandonment and his frightened mother tossed in his mind. At one point, the pastor mentioned the crimes Monroe had committed. The list included swindles, slave smuggling and forgeries that stretched from Texas to Britain. In that moment, Luckey saw a glimmer of complete coherence. It lasted long enough for Monroe to deny committing every single act. With that, he had completed his final swindle. He convinced himself he'd lived a different life.

Then, he died.

2

PARADISE LOST

The world welcomed Monroe's birth in the closest land it had to the Garden of Eden. At the turn of the 1800s, Danville, Kentucky, was flourishing with rushing rivers, green hills and majestic mountains that rolled into lush valleys. The land looked like heaven's angels had flown down to bless it with kisses.

Danville was home to Baptist farmers who migrated from North Carolina, Pennsylvania, Maryland and Virginia. To reach their new homes, they had to fight for every step they took.

Sixteen years before Monroe was born, Danville had attracted the fancy of eastern colonists when it became the birth site for the fifteenth state. Kentucky was no longer a county of Virginia, and Monroe's grandfather had everything to do with this. The United States had become dazzled with these mountainous meadows twenty years earlier, when trailblazer Daniel Boone, Monroe's grandfather's friend, gave accounts of his times in the heavenly wilderness.

John Edwards was born in 1748 and lived in Stafford County, Virginia, for most of his life. He stated that he served in the Revolutionary War in 1776 as a senator of a militia that guarded the western frontier of Virginia. He said he did that until 1780, when he arrived in Fayette County, where he served with a commissary general. He supplied troops and fought the Indians who surrounded the Wilderness Road, the key passageway to the West. Pioneers used the Wilderness Road to cross the Cumberland Gap. While Edwards guarded the frontier, Boone was exploring ways to make

the road wide enough to accommodate wagons so more settlers could move west.

The Cumberland Gap was named for the Duke of Cumberland, son of King George II. In the 1750s, Thomas Walker found one of the few gaps in the Appalachian Mountains and named it the "Cave Gap." Nearby, he found a river, which he named after the duke. Soon, the gap and the river became known by the name Cumberland. Eventually, the surrounding mountains would bear the duke's name as well. Expanding the passageway was critical, and Boone's efforts, backed by private companies, were pivotal to settling Kentucky and Tennessee. The Cumberland Mountains had other routes, but the gap was the only continuous one. It was not an easy journey.

The Iroquois Indians named this land Kentucky, which meant "the meadow lands." For centuries, they relished the beauty, bounty and majesty of the mountainous region. In the 1770s, political wrangling began. The tribes and Great Britain fought over land purchases. The result of the feuding left some groups of Indians angry. These groups, led by the Shawnees, refused to leave their homelands. They plotted ambushes and strategic attacks along the two-hundred-mile route to defend their territory against the pioneers. White people stayed armed with guns, axes, scythes and other weapons. The gap was the entrance to a war zone. If the Indians didn't attack along the Wilderness Trail, robbers did. If humans weren't the problem, wild beasts were. If neither of them killed a settler, the harsh weather might. This dangerous journey meant settlers could bring few belongings. They had essentials and a few head of cattle. Land hungry, the men would use their possession warrants from the military to secure a few hundred acres. If they didn't have that, they'd squat on land near the plentiful rivers.

Within a year of his Fayette County arrival, Senator Edwards accumulated twenty-three thousand acres from the government for his service at the gap. He married Monroe's grandmother, Susannah Wroe. He claimed up to twenty-four children in total, ten of whom he had with Susannah. These included Monroe's father, Amos (who was called Moses), and his uncles Benjamin and Haden. Senator Edwards and his family lived on their plantation homestead, Westwood. The large, two-story home overlooked Cooper's Run in Paris, Kentucky. It had orchards, vineyards and one of the few wineries in the area. The senator had many farms, gristmills and stores in Paris and Washington.

Because Fayette County was part of Virginia at the time, Senator Edwards became a member of the Virginia House of Delegates. In 1786, he was a clerk for the newly formed Bourbon County, Virginia. This neighborhood

would eventually become a Kentucky county. In 1788, he was a member of the commission that would determine Kentucky's new state boundaries. Four years later, in 1792, he was a delegate to the convention that drafted the first Kentucky constitution. He was immediately elected as one of the first two United States senators for the new state. He served with John Brown until 1795. After his service in Washington, D.C., Senator Edwards returned to Westwood and served in the state legislature until 1797.

Then his life took a strange turn that has no explanation. He left his wife and ten children and moved into Duncan Tavern, a popular inn in his hometown. Boone and almost every adventurer, as well as notable and wealthy travelers, are known to have stayed there when they passed through the area. He had a slave woman, Priscilla Johnson, with him. For reasons unknown, he never paid his bill at the tavern, and the management later sued him for the money. Other financial troubles plagued him. His father, Hayden Edwards, had given him a loan. In his will, the elder Edwards stated that the senator must repay the loan of "several hundred pounds" or be disinherited.

Senator Edwards then sold Priscilla, his slave, to a friend, who emancipated her immediately. It wasn't the first time the senator sought freedom for a slave. In 1802, he freed a mixed-race slave named Winnie Jason. After Priscilla was freed, Edwards deeded Westwood and its four hundred acres to Susannah and their ten children. Then he racked up debts for an unclear reason. The loan to his father was never repaid. It appears he tried to pay everyone else, though. He filed for bankruptcy between 1800 and 1804. Haden and John Jr. handled the process for him while they tried to sell virtually every asset their father owned—and there were plenty.

Senator Edwards sold eight buildings that faced the courthouse and the lots they were on. One was a two-story frame building with large brick fireplaces and six rooms finished in plaster. He also sold nine acres with buildings that were originally worth $8,000 before he made improvements on them. He was willing to sell them "very low and give them clear of incumbrance [*sic*]." He sold two oven-shot gristmills that would be ready for the next season. They were built with Burr and Allegany stones. "Those mills in the season for grinding can make 40 barrels of flour every day that they are worked," he said in his advertisement. He claimed anyone would know the mills made better flour than any boated into the county. The mill came with a slave, a miller, a 140-acre plantation, 100 apple trees, a clover and bluegrass pasture and a meadow. He would also throw in the home and farm, outhouses, a cherry orchard and a peach orchard. He said he had paid $9,000 for all of them two years earlier.

He also sold seven hundred acres of the land he received from the government for his military service. It was northwest of the Ohio River near a salt lick. Additionally, he sold two of his small plantations in Bourbon County, and he was willing to sell an eight-thousand-acre plat. The first four thousand acres of that plat he was willing to sell for one-third of its value. The list of acreage and mills went on. He also sold all his hogs, cattle, mares and colts with the mills. He sold the merchandise, horses, slaves and all the flour he had in storage.

Monroe's parents, Moses and Penelope Ashmore, were married in 1801 in this new state his grandfather created. Two years later, Senator Edwards left Kentucky for Missouri. He took Priscilla with him, and they traveled between Ohio and Missouri for several years. At some point, his finances rebounded because he operated a store and owned mills near Mason County. Monroe, who likely never met his grandfather but knew of his legacy, was born in or around 1808. His mother also had two girls, Polly and Minerva, who may or may not have been twins. His brother, Ashmore, was born at

MONROE EDWARDS AT THE AGE OF SEVEN.

some point later. His youngest sister, Penelope, was probably born in or around 1814. They were born on a piece of land Moses inherited from his father. It was along Cooper's Run and came from his share of the Westwood plantation his father left the family.

Senator Edwards never returned to Kentucky. He built a new life with a new family in Missouri. In 1817, Priscilla named Senator Edwards as her attorney for all her transactions. He was also named the guardian of her children. He filed a war pension claim and gave an account of his service in the Revolutionary War and at the Cumberland Gap. He never received a pension, though. He died in 1833 or 1834 in Missouri before the paperwork was finished. His story about his wartime experience was never verified.

In his will, the senator left one-fourth of his remaining land to Monroe's aunt Jane Beall. Monroe's uncle John Jr. received another fourth. They traveled to Missouri to settle their father's estate. The remaining half of his land was given to Priscilla and her children. In the senator's final act, he also freed all his slaves and their children.

The first senator of Kentucky ended life as a disinherited son who left behind the legacy of a prominent, celebrated, noble and unfortunate existence.

3

MONROE'S BENT

Moses carried on in Kentucky after his father's abandonment, while his brothers Haden and Benjamin moved to Mississippi. Moses built a good reputation for himself and worked a considerable amount of the four hundred acres his father left the family. He was amiable and popular.

Moses was always looking for a better life and instilled in his children the idea that they could always succeed. One journalist who chronicled his life surmised that perhaps it was the dismal experience he had with his father that drove him:

> *He was a man, however, who cherished high notions of personal importance and the dignity of wealth, and as may be supposed of thus bent, he infused into the minds of his children, those false notions of supercilious pride and consequent extravagance of expectation which has been the perversion and ruin of so many ardent and aspiring spirits.*

Specifically, Moses believed money brought quality of life, and he was searching for both in Kentucky and Tennessee. That is, until the states turned on him.

Within two years after his father abandoned the family in 1819, Moses considered expanding into Clarksville, Tennessee, and starting a store there. He had a partnership with Robert Leftwich and Henry C. Sleigh. They began the effort, but soon the entire partnership fell into bankruptcy, and the men disbanded.

Monroe was about eleven years old when his father lost everything. Some records claim Moses also lost his crops and his slaves got sick and died. Another said he was the victim of forgery, and his name was stolen. Whatever the case, Moses spent some time struggling to keep his homestead and property. These issues didn't taint his friendship with Leftwich. Within a year, Moses was back in business with him.

Their new venture began when tales of the prosperous land in the Mexican Republic reached the Cumberland Mountains. Moses and his partner created the Texas Association. They found seventy-seven other speculators to join them in their effort to build vast Texas plantations that would make them wealthy in their own colony. Moses invested the most money into the business and maintained the largest share. They petitioned the Mexican government in March 1822.

One year later, Haden's friend Stephen F. Austin got the first grant to colonize three hundred settlers. They were bringing pioneers to the fertile and rich land around the Brazos River. Moses wanted to join Austin, his brother and his brother's friend in settling Texas.

The future was looking bright for the Edwards family. The Texas Association agreed to let Leftwich handle negotiations as their representative to the Mexican government. Moses then made a critical decision. Leftwich would take Monroe with him to New Orleans. Once they arrived, Leftwich would leave the boy with James Morgan, a family friend. Then, Leftwich would head to Mexico from there. Moses decided that leaving Monroe with Morgan was the best way to stabilize the family while their finances rebounded. Morgan was building a small but profitable business in Louisiana and could care for Monroe. Moses said he knew Morgan "would take care of his favorite son." Monroe's brother, Ashmore, and their sisters stayed behind with their parents. The separation wouldn't be for long. Soon, the entire family would be in Texas. One journalist who chronicled his life noted, "Mr. Edwards, soon after this division of his domestic circle had occasion to find that the disposal of his children had been prudent. Misfortunes followed him in rapid succession."

Morgan was born in Philadelphia, but his family moved to North Carolina when he was a child. When he grew up, he married Celia Harrell, and they had a family. He traveled between his North Carolina homestead and New Orleans, where he was building a store with his partner, John C. Reed. Monroe would work with the two men until his father called for him in Texas. The move hurt Monroe. He didn't want to leave the Kentucky meadows and go to a bustling port town. Years later, he wrote a poem that

described his heartbreak. He loved the mountainous land and had a happy Kentucky childhood:

> *Farewell, lovely valley, your beauties are bright*
> *As the time hallowed visions of childhood's delight;*
> *Thy memories more deeply are traced on my heart,*
> *Since fate has decreed that I from thee depart.*
>
> *Farewell to thy green field, farewell to thy groves,*
> *The home of my boyhood, the scenes of young loves!*
> *Ah! never again shall the future restore*
> *Those halcyon days, those pleasures of yore.*
>
> *Farewell to thy rippling waters, that run,*
> *Now shaded by willows, now bright in the sun,*
> *Where oft in my childhood, the summer day long,*
> *I've listened in ecstasy to the mocking bird's song.*
>
> *Farewell, ye green woodlands, under whose shade*
> *From the sun's heat at mid-day, so oft I've strayed,*
> *Where oft I have linger'd, in solitude blest,*
> *'Till the Day-God has hidden his face in the west.*
>
> *Farewell, scene of beauty—there brighter may be,*
> *But to my eye Earth's beauties are nothing to thee.*
> *In my dreams, where afar o'er thy green hills I roam,*
> *And ever shall claim only thee as my home.*
>
> *Farewell! What a bright pictured dream is the past!*
> *Alas! much too beautiful ever to last.*
> *Young hopes are like lover's dreams, bound to decay,*
> *As dew from the morning rose passeth away.*

With Morgan, Monroe showed a great aptitude for business, and he had an intuitive comprehension of it. He grew fond of Morgan's daughter, and they became playmates. He was smart and could grasp complicated mercantile transactions. Only two problems plagued the young man during this time, Morgan said. Monroe "was too handsome and too fond of pleasure."

MAMIE MORGAN, MONROE EDWARDS' PLAYMATE.

Mamie Morgan was a favorite playmate of Monroe Edwards in New Orleans.

While his later years reveal Monroe may have been forever homesick for Kentucky and acting out, to some extent, he was also enamored with the wealth and culture of New Orleans. A journalist who wrote an account of Monroe's life said the boy enjoyed a fancy lifestyle more than hard work, and he soon began staying out at night and enjoying "loose living." When he was left alone, he'd sneak out of the house and "go do wild things," to which he

alluded later in life. He never went into detail, though. Morgan would scold him and tried to convince him that he was going down a wrong road, but Monroe didn't listen. The journalist said, "Mr. Morgan, after lecturing him duly on the perils of late hours and loose life, left him to follow his own bent, under such restraints as he supposed the young man's commonsense and regard for his good opinion would impose."

Like other headstrong children, Monroe, when interviewed, said he crafted a plan to sneak out at night. If Morgan was in the house, the teen said he would jump onto a shed underneath his bedroom window. Then he would sneak through the yard to the rear gate, where he had a cadre of friends, including adventurers and slavers, who would meet him. They'd stay out most of the night. Morgan paid him a good salary, and Monroe later said he squandered it living a fast life in New Orleans. During this time, he made lifelong friends who would affect him until his final days.

The young man's new neighborhood was a world away from the life he knew on Cooper's Run. New Orleans was sophisticated, elegant and splashy, with people from all over the world rolling into a melting pot that blurred lines that had been clear in remote Appalachian towns. His grandfather fought Indians in the Cumberland Gap. In New Orleans, they were French Market merchants and sold gumbo or native herbs to young boys. New Orleans in the 1820s was bustling with a worldwide economy. Its port activity rivaled New York and outstripped Boston. The War of 1812 was over, and the coastal town bounced into its antebellum period with a few quick dance steps. It had twenty-seven thousand people and was the leading southern city. Languages muddled together in the French Quarter. Free women of color would sell coffee from their own businesses. Food choices were vast—wild game, fish and vegetables seemed to never end. The port brought all sorts of luxury items right outside a person's gate. Liqueurs, sausages, anchovies, pickles, fruit preserved in brandy and dried fruits could all be purchased for a few coins.

The melting pot blended the races and cultures. Voodoo was a common sight in Congo Square. Mixed relationships were open and accepted. Money was never a problem. Sanitee Dede, Marie Laveau and "Dr. John" Montenet enthralled white people, who would watch them lead slaves and free blacks in African-style drumming, dancing and rituals.

The flavor of Europe mixed with this culture when famine-starved Irish and Germans began immigrating to the city faster than they were on the Northeast coast. Their anti-British sentiments found sanctuary in New Orleans. Soon, they had settled along Canal Street and created a labor

force to be reckoned with. They were celebrating holidays and festivals. St. Patrick's Day was already part of their heritage by the time Monroe was sneaking out at night.

In all of this, he saw that his grandfather's relationship with his companion, Priscilla, was not uncommon at all. White men were allowed to take black mistresses and have children with them. And like his grandfather—and unlike in other parts of the South—New Orleans men acknowledged their mixed-race children. Sometimes the men would even marry the black mothers of their children. Their children received a quasi-legal status known as "placage." The term is French for "veneering." Only death could end the placage. Creole sons could meet mixed-race girls in quadroon balls with the dream of one day becoming part of a conventional marriage.

The city also had an underbelly. European immigrants lived in slums, and many died from disease brought by mosquito bites. Life could be seedy, nasty and dirty. The New Orleans slave market revealed a contradiction to the tolerant culture of placage. While Monroe tutored under Morgan, the United States passed the April 1818 slave law. It coincided with the launch of the British abolitionist movement in which Brits began a worldwide attempt to stop the slave trade.

Overall, the measure was a weak attempt at outlawing slave imports. It called for imprisonment, fines and forfeiture of a slave-trading vessel. Instead, the law created an uptick in profitable slave smuggling because enforcement was so poor. The law instructed navy vessels to guide slave ships back to Africa, where they would release their human cargo. Some captured slaves were sent back to Africa, but most were not. They were turned over to customhouses. Customs officials would sell the slaves to recoup the enforcement and prosecution costs for capturing the slave ship. If officials caught slaves on land, sometimes they returned the slaves to the planters from whom they seized them. Technically, the planters were given the slaves under a bond. They would just forfeit the bond and keep the slaves they already owned.

In the case of popular slave smuggler Jean Lafitte, who was establishing a new headquarters in Galveztown in 1818, the loopholes were a business opportunity. Slavers created an organization of smugglers along the coast. Their racket bypassed the law and made them wealthy very quickly. Lafitte scoured the seas for slave ships and captured them. Then he would sell the seized slaves to another smuggler, such as Jim Bowie, at a discount. The smuggler would march the slaves to Louisiana and turn them into customs officials, who would sell the slaves at auction. When the slaves were up for bid, someone on the smuggler's team would buy them back for him.

Then, in moves difficult to comprehend, the government would give the smuggler 50 percent of the auction profit. On the other hand, if Lafitte or another smuggler brought the entire vessel to the government, the smuggler not only received the auction profit, but he also received 50 percent of anything that was sold from the ship itself. As the law states:

> And the proceeds of all ships and vessels, their tackle, apparel, and furniture, and all goods and effects on board with them, shall be so seized, persecuted and condemned shall be equally divided between the United States and the offices and men who shall make such seizure, take or bring the same into port for condemnation, whether made by an armed vessel of The United States or revenue cutters thereof, and the same shall be distributed in like manner as is provided by law for the distribution of prizes taken from an enemy.

After the auction was finished, the smuggler's team member would bring the slaves to him. The slave smuggler was now free to traffic the Africans in the Deep South and make yet more profit. It would be several more years before the government would call slave smuggling by another name: piracy.

INDUSTRIOUS YOUTH OF MONROE EDWARDS.

By both names, Lafitte and his ring made money off the misguided U.S. slave policies. This scenario was one that a young Monroe watched while he was in New Orleans with Morgan.

In Kentucky, Monroe would have been married or betrothed by now. In New Orleans, Monroe was becoming a man more interested in economic adventures and the big life. He was learning lessons he would use to achieve the prosperous, comfortable and luxurious life his father wanted his children to have.

4

THE UNCLES

Monroe's uncles Haden and Benjamin did not waste time in leaving Kentucky after their father deserted them. By 1820, they were in Mississippi, where they and their families had a vast, wealthy plantation. Haden had thirteen children with his wife, Susanna Beall of Maryland.

Within a year or two, Monroe's uncles learned that plantations could be bigger in the unbridled Mexican territory called Texas. Their friend Stephen F. Austin told them about a groundbreaking deal his father, Moses, had with the Mexican government to colonize the territory.

United States settlers, like the Austin family and the Edwards brothers, were driven to the undeveloped land of Texas for the chance to strike it rich on cheap acreage. What their imperious imaginations didn't consider was what they would leave behind. They didn't just leave their homes and families to find their fortunes; they also left the protection of being United States citizens.

As a member of Austin's Colony, settlers moved from British-inspired rule to Spanish-inspired government. That distinctive change meant a great deal. Spain came with a different perspective on life, and the cultural reference was different than Britain's. The idea of leaving national protection didn't bother these pioneers too much. They gave barely a nod to the uneasy politics and social differences. Most settlers believed it was only a matter of time before the United States finished acquiring this land. Being settled in it now meant they were on the front end of this new expansion. Soon, the United States would expand the wealthy southern plantations that supplied Europe with its prized cotton and merchandise.

Stephen F. Austin's father, Moses, was the earliest land speculator who had a contract with the Mexican government to settle the new land called *Tejas*. When he died unexpectedly, Austin asked Haden to come with him to Mexico to negotiate Moses's contract. Austin wanted to keep his father's dream alive and finish his ambitious plans. Haden had more money than Austin, and many times, Haden funded Austin's plans for him. He helped Austin convince the Mexican government to start the colonization of Texas.

Mexico and Spain never had much interest in Tejas. Their governments preferred to remain on the waterways and never ventured far inland. They stayed off the shores, and Spaniards never had an interest in settling Tejas. When Haden and Austin traveled to discuss Moses's contract, the Mexican government was happy to work with them to build the republic. The younger Austin inherited a huge territory that he could settle on behalf of Mexico. It did not include Galveston Island, but it did include the mouth of virtually every large Texas river. He chose the Brazos River as the birthplace of his new colony, but his settlements stretched both ways from there.

At the time of the burgeoning Austin-Mexico relationship, the only form of tension was the issue of slavery. Spain did not rely on slavery as a form of economic progress, so it was never discussed in early colonial grants. It is quite possible that Haden Edwards didn't even have to negotiate the point when he stayed in Mexico after Austin returned to Texas. The government had an assumption that its territory would be settled without slaves. It wasn't until years later, in 1830, that Mexico would get serious about the matter and outlaw slavery. As part of the southern plantation system, Austin saw slaves as an economic necessity. He allowed his colonists to bring their slaves and gave them extra land if they did. Mexico, glad to have someone interested in colonizing the dense coastal prairies surrounding the massive rivers and waterways, looked the other way. It was always a touchy subject but never a breaking point. The worldwide slave trade didn't muster Mexico's wrath. Immigrants did.

Austin was given restrictions about the kinds of colonists he could allow into his colony. To settle new Mexican land, a pioneer had to be believe in the Christian god and Virgin Mary, just as the ruling nation. He had to have funds to cultivate the bountiful cash crops and had to read and write so he could create contracts, send letters and administer the colony. In short, Austin had to entice a well-heeled section of Roman Catholic pioneers from the United States. After he culled the best of the South, where Haden and Benjamin were located, he began marketing to the North. Those efforts likely helped Moses when he and Leftwich formed the Texas Association.

When the legend of Texas reached the Northeast between 1824 and 1830, pioneers rushed in. Their numbers were limited only by the sheer number of grants Mexico gave to empresarios like Austin and Haden. When the settlers arrived, according to Mexico, most did not meet the criteria to become Texas pioneers. The Edwardses, for example, were Baptists.

Through Haden's relationship with Austin, the Kentucky Baptist soon became an empresario himself. He had the right to bring eight hundred families in and around Nacogdoches, the controversial and oldest city in the New Republic of Mexico. Becoming an empresario was a great help to the settlers. Without one, a settler had to petition local government officials by himself. The government was supposed to tell the person where he could settle and obtain the title for him. That became complicated because most of the land was under a colony grant, which meant unclaimed land was scarce. The language itself was a barrier to the entire process. Few United States citizens spoke Spanish. That made empresario colonies the most attractive method of settling Texas.

Haden's contract, known as Edwards Colony, was given at the same time as Robert Leftwich received his. The fact that both of them stayed in Mexico City after Austin returned to Texas may be one important reason that two major colonization laws existed. The 1824 colonization law and the 1825 law that allowed empresarios to bring settlers to Texas were negotiated while they lobbied the government on behalf of themselves and Austin. Six weeks after the law was passed, Austin received word that contracts had been issued to permit the settlement of 2,400 families.

When Haden arrived in Nacogdoches with his grant in April 1825, the settlement was already a thriving community that boiled hot with extreme politics. Some of the land grants were more than a century old. The community itself had a long-standing filibustering history with Philip Nolan and James Long, who used it as their headquarters. Nacogdoches was known as the epicenter of the movement to free Texas from Spain. In 1819, Long made his first filibustering expedition to capture Nacogdoches and was successful. As a result, his followers named him the first president of the Republic of Texas. The title meant nothing, though, and is not included in the official chronology of events that led to the Texas Revolution. So, while Haden was allowed to bring eight hundred new families to the area, the number for a premium contract, he was actually given the right to colonize an area that was already a recognized Texas settlement.

Texas settlements were helped by the Louisiana Purchase in 1803. At the time, President Thomas Jefferson said Louisiana's true boundary stretched

to the Rio Grande, which made Tejas a United States territory. At the time, many people in Washington, D.C., agreed with him. Their notion became a bit precarious in 1819, when the Adams-Onis Treaty claimed that the United States gave Texas to Spain in exchange for Florida. In other words, the United States surrendered Texas. For the moment, however, that wasn't an issue anyone brought up. The sentiment that Texas was part of the United States was still embraced by some settlers migrating from the Northeast. At first, Mexico welcomed these immigrants, regardless of their stature, religion, politics or education. With three sets of laws between January 1823 and March 1824, Mexico revealed a liberal view toward the settlers, regardless of how they arrived. It didn't matter if Austin beckoned them or if another adventurer's tall tales had convinced them to come. This welcoming policy did not change even as Mexico overthrew its emperor, Iturbide. He lost rule just a few months after Mexico passed the first immigration law. In fact, an important point in the law of August 1824 seemed to ensure that a new Mexico Republic would welcome immigrants for some time. It was found in Article 7: "Until after the year 1840, the general congress shall not prohibit the entrance of any foreigner as a colonist, unless imperious circumstances should require it with respect to the individuals of a particular nation."

The only troubling clause was the "imperious circumstances" that might arise. No worries. Just like the boundaries of Texas, for the moment, all were welcome. For decades, the United States had wanted to expand west, and the wilderness of Texas captured the fancy of Washington, D.C. With the influx of northern immigrants heading there, Congress saw a chance to push forward negotiations. President James Monroe was concerned about the stability of the new Mexican government and how that might affect some of the outstanding points he had with Spain. The issues over the western boundaries kept knocking at Capitol Hill because the U.S. government wanted to expand into Texas. Legislators made several unsuccessful attempts to convince Spain to sell. When those failed, they asked for a treaty that would create "neutral" zones. At one point, the land where Austin settled would have been under one of these zones, but that didn't happen. Neutral zones were drawn and soon figured in the colony Monroe's uncle set up.

At the end of the Mexican revolutionary war, Washington wanted to get the boundary issue on the table again. To push the matter, it sent Joel Roberts Poinsett, a world-traveled, well-heeled, upper-class Charleston politician and diplomat. He served the Carolinas in the U.S. House of Representatives, but his true mission was to serve as a special envoy to Mexico. Poinsett spent 1823–24 learning about Mexico and building a relationship with Iturbide.

A detailed and flourishing two-hundred-page record he wrote recounts his travels during the Mexican Civil War.

A year later, he resigned his House seat and became the first U.S. minister to Mexico. In post–civil war Mexico, Poinsett was asked to finish the set of negotiations that began with Spain. These talks had stretched on for decades. Poinsett was expected to make amends and build a foundation with Mexico. In specific terms, he was tasked with settling the boundary of Texas as mentioned in the 1819 treaty. In the United States' interpretation, that document delineated a boundary line between Louisiana and Texas, but it was never drawn. To complicate matters, the United States argued that the messy oversight meant the Treaty of Cordova between Spain and Mexico in 1821 lacked a boundary. The United States had been dealing with Spain for years over the matter. Mexico, now free from Spain, was the new party with which the United States would have to deal. Poinsett failed to negotiate a line in 1825. He wouldn't resume negotiations until 1827.

That left the Edwards brothers enough time to get settled and start a rebellion that would lead to a revolution.

5

FREDONIA

aden's friendship with Austin began to cool off after his friend's colony started to flourish. Haden thought Austin was getting greedy. Being an empresario didn't make a person rich immediately; rather, he was paid with land, which he could sell or keep and build on. Haden thought Austin was convincing Mexico to give him all the best land, leaving lesser leagues to other speculators like himself.

In all fairness, Haden had been given a difficult grant, whether or not due to Austin's maneuvering. Nacogdoches was bordered by the neutral zone, where fugitives and bandits tended to hide. He had Indians to the north and west of him. Austin's Colony had undeveloped land with fertile soil and what may have been the most perfect Texas river. He had features that would entice settlers. The mere fact that Nacogdoches still resounded with the remnants of Nolan and Long's rebellious filibustering kept Haden's hands full. The chances that he would have many grants at all was low. Before he became empresario in 1825, only thirty-two grants had been made, and only one lot had been sold to someone else. East Texas was not a place to get wealthy and expand an empire, despite what his friend Austin seemed to have been able to manage. Haden was not handling the situation well. He acted out with threatening behavior, and it was causing more damage than he probably realized.

His first act as empresario was to nail notices on street corners that told veteran settlers to prove they owned their land or give up the leagues to the new settlers he would bring. Before long, Haden had enemies in his own

colony. His post made it clear that he didn't want squatters. According to historian Eugene Barker, it read:

To all who shall see the present know that I, Haden Edwards, empresario and military commandant of that portion of the state of Coahuila and Texas which has been conceded to me by the authorities of said state, and in virtue of the powers which have been delegated to me by those authorities, have decreed, and by the present do decree and order, that every individual, or family, resident within the limits of the specified territory and all those who claim to have a right to any part or parts of the land or lands of said territory shall present themselves to me and show me their titles or documents. If any they possess, so that they may be received or rejected, according to the laws; and if they do not do this, the said lands will be sold, without distinction, to the first person who occupies them. Those who have valid titles will be obliged to bear the cost of proving them.

Haden didn't post this message once. He posted it twice, even when he didn't have the authority to do so. His grant actually mandated that he would honor any squatters because Mexico knew he had so many. In his defense, he needed to know who was a settler and who was a squatter, but his style offended almost every existing settler. They began complaining about him. Many asked Austin if they could have other land, closer to the coast, just to get away from Haden. The complaints startled Haden when he found out about them. Ironically, he learned about them after he returned from a visit with Austin. He wrote to Austin two months later to tell him about the experience. Haden's ego was on display:

I found upon my return from your place that there had a considerable storm arisen, heavy threats to send me over the Sabine: but I came out of a Herricane [sic] and promised to send in irons any man who dared acknowledge the threat to Saltillo. Sounded the trump all around bidding defiance to all their threats and bidding them to leave the lands or come forward and make arrangements to pay for them. They are now all friendly, promise to pay me for their lands and spend their lives in my defence.

The problems with his bullying ego continued. Relationships in Nacogdoches and Edwards Colony soured. After many months of arguing and threats, Austin wrote to Haden and told him, in frank terms, that he needed to heed some sage advice about his temper:

The truth is, you do not understand the nature of the authority with which you are vested by the government, and it is my candid opinion that a continuance of the imprudent course you have commenced will totally ruin you, and materially injure all the new settlements.

In a sense, that is exactly what happened. Empresarios did not actually rule their grant lands; rather, they were part of a system that included an alcalde, who was the most important person in town. The alcalde served several functions at once. He was the mayor of the council, the justice of the peace and the city manager. Residents voted for this person, and in December 1825, votes were being cast in Nacogdoches. The old settlers offered Samuel Norris as their candidate. Haden and the new settlers offered one of his son-in-laws, Chichester Chaplin. When Haden reported to the political chief in San Antonio that Chaplin won, the old settlers cried foul. Saucedo, the Mexico political chief, reversed the decision. Haden did not like it, and neither did the new settlers. Haden did not back down and would not surrender all the documents Norris needed to begin his term. When Mexico found out, it forfeited Haden's grant mid-year in 1826. Haden was fuming with anger. The feuding continued.

Soon afterward, Haden left to sell his grant in the United States. His brother Benjamin took over control for him in his absence, and he had an even more difficult time than Haden. The newcomer didn't know all the history that had taken place. He didn't speak Spanish and relied on gossip and rumors to help him master the situation. The entire community eventually fell apart, and he unwittingly inflamed the situation with Mexico. Given its history with Haden, Mexico was ready to march on Edwards Colony at a moment's notice. By the time Haden returned, the situation was hitting a fever pitch. His grant wasn't sold, and now the new settlers concocted a scheme to settle the score: they were going to regain Nacogdoches and Edwards Colony for Haden.

In November 1826, Martin Parmer, John S. Roberts and Burrell Thompson led thirty-six of Haden's supporters from Ayish Bayou to Nacogdoches. They kidnapped Norris and Sepulveda. They also captured Haden to make the coup look real. They kidnapped a few others, too. The trio tried them all for oppression and corruption. Haden was found innocent and released. The rebel court convicted everyone else. The prisoners were sentenced to death, but there was one caveat: they could resign from office and live, which they did. The rebel court named Joseph Durst as alcalde.

When Mexico heard of the coup, it sent 20 dragoons and 110 soldiers to control the rebels. Haden considered his next move and poorly borrowed

from the legislative lessons of his father. He decided that the only way to save his $50,000 investment in Edwards Colony was to create a new state or republic. The coup created the Independent Republic of Fredonia. They made a flag and signed an alliance with the nearby Cherokees. They wrote and signed a declaration of independence. Benjamin was the commander in chief. He asked the United States to help the Fredonian people against Mexico. The U.S. Congress did not comply.

Haden was elected president. He asked Austin to help him, but Austin wanted nothing to do with Fredonia. Instead, Austin went behind the scenes, where he negotiated and pleaded with the Mexican government to let the situation end peacefully. When the Mexican military showed up, Haden and the rest of the Fredonia militia ran. They ended up on the far side of the Sabine River, where the Cherokees killed two of the rebels for involving their tribe in the nasty mess to begin with.

Haden and Benjamin escaped unharmed, but the legacy of their misguided antics would reverberate throughout Texas for years. Like their father, they created history.

6

THE NASHVILLE GRANT

While Haden was trying to manage the bungled boiling pot his hot temper had gotten him into in Nacogdoches, Moses Edwards was having his own troubles. He still wanted to bring eight hundred families to Texas and meet Monroe there. The Texas Association grant was taking much longer than expected because Iturbide fell. One of the results of that meant the Mexican government moved to a federal form of government similar to the United States'. That meant only Austin's first grant would remain under Spanish law. The others followed the National Colonization Law in 1824 in which Haden and Leftwich had been instrumental. This was one of the first acts the government passed after the fall.

Tejas was now the "Coahuila and Texas" state. The state gave Leftwich a colonization contract in 1825, the same year Haden received his. The approval came too late. Moses was funding the Texas Association almost exclusively. Money ran out during Mexico's political unrest and aftermath. Moses gave Leftwich more than $20,000 during the year only to see him return to Tennessee with a contract in his name and not the association's. It cost Moses more money when Leftwich sold the contract back to the Texas Association. Now, the association had the right to introduce colonists to the area. The contract was for land in the present-day lush Hill Country counties of Bastrop, Bell, Brazos, Burleson, Burnet, Comanche, Coryell, Falls, Hamilton, Lampasas, Lee, Limestone, McLennan, Milam, Mills, Robertson and Williamson. It was later extended to include the present-day counties of Bosque, Brown, Callahan, Eastland, Erath, Hill, Hood, Jack,

Johnson, Palo Pinto, Parker, Somervell and Stephens. In 1827, Stephen F. Austin began to refer to the contract as the one from the "Nashville Grant Company." The name stuck for many years.

Moses's troubles got worse. None of the original speculators was moving to Texas, and that meant Moses was not recouping any of his money. He himself was still not in Texas, and he had not seen Monroe for five years. Moses encountered one crisis after another, "which during the interim between the years 1822 and 1825 so disastrously struck the west, he became thoroughly involved, or to use a plainer and more appropriate term for that condition—thoroughly ruined."

He eventually decided to push forward. Even with the collapse of the Nashville Colony, he was going to finish his plans to rebuild in Texas. As journalist George Wilkes chronicled, "Though nearly broke in mind by this tremendous reverse in his condition, he still retained sufficient composure to take a patient survey of his affairs, with a calculated view for the future."

In July 1828, Moses arrived in Nacogdoches with Penelope, his youngest children and slaves. There, he found his brothers in the aftermath of their Fredonian Rebellion. He wrote to Austin that he did not approve of their actions and made sure Austin knew he was bankrolling the Nashville deal. Moses left his family with his brothers and searched for land to settle so Monroe could meet them.

Undaunted, Moses was ready to purchase property and work within the tenuous system that his brothers and Leftwich had helped create in Texas. He was losing faith in Leftwich and wrote to Austin to tell him that he might prefer to become a member of Austin's settlement instead. He wanted to help Leftwich bring settlers from their neighborhood to Texas, and that didn't seem to be happening. In a letter to Austin, Moses wrote:

> ...But I begin to think that the Grant will never be colonized unless some three or four of us take on all the trouble upon us, pay all the expense, and undergo all the privations, dangers and difficulties of colonizing the Grant and then give the company their full share of lands without charge.

He told Austin that he had asked the company in March to meet so they could create a plan to move to Texas. He was even willing to take the grant himself and execute it for them. The request fell flat: "I have determined to locate myself where my judgment induces me to believe is best for my private interest."

By March 1830, he had bought a league from Stephen F. Austin along the banks of Galveston Bay so his family would have a settlement. That

year, the family was also reunited with twenty-two-year-old Monroe, who traveled from Louisiana to help his father. The property was directly across the channel that separated the island from the mainland. Galveston was not under any grant Austin had with Mexico, so the colony's settlers, like Moses, tended to have property on the mainland that surrounds the island. In Moses's case, the sale was "site unseen." Austin never saw the leagues he sold to Moses and neither did Moses.

A year later, in 1831, Moses realized the Nashville Grant Company would never colonize. His hopes of creating his own settlement were turning into disappointment: "They have done nothing towards colonizing the grant but have sold their shares to speculators who will probably try to get the grant for themselves."

Moses never did become an empresario, and much of the reason was because of Austin. The colony contract became entangled in politics between Austin, Moses and a former Texas Association speculator, Sterling Clark Robertson. Moses pleaded with Austin to help him get the contract in his name. Behind his back, Austin promised to help Robertson get the contract instead. Robertson was having better luck than Moses in convincing colonists to settle in Texas, and Austin benefited from that. Robertson's method was to settle them in Austin's Colony because the 1830 immigration law would not let them settle elsewhere. Moses, on the other hand, was trying to get control of the grant before he began bringing settlers down. Austin double crossed both and got the grant put in his name instead. He told the state that Robertson and Moses had never tried to settle the Nashville Colony. According to the letter of the law, empresarios had six years to get at least one hundred families into the colony. That double cross began a round of legal battles, and the politics that ensued stymied the growth of central Texas for years. In the end, Robertson became empresario, and his settlers lived in Robertson's Colony.

Unlike Robertson, Moses never recovered from the fall of the Texas Association. Moses's leagues from Austin were at a site that became known as Edwards Point. This was near Red Fish bar on the south side of Galveston Bay. It bordered the bay and Dickinson Bayou. In modern terms, it was the land that is now known as Texas City, San Leon and Bacliff in Galveston County. Today, Edwards Point remains an actual spot on Moses Lake and Dollar Bay in Texas City. It was not an easy settlement. The land was like nearby Galveztown—difficult to build on. Moses wrote to Austin from what he called Davis Point that he was living

in a large tent with his entire family: "When I came on I found my hands were trying to make some improvements and I concluded to settle here altho there is not a tree of timber suitable for nor any building or fencing nearer than 5 miles of this point nor any running fresh water within 4 miles."

He said farming was difficult, but he planned to keep stock so that was of little concern. He would plant corn and potatoes, but he told Austin it would be hard. Moses regretted the purchase and told Austin he was sure that the empresario would never have given it to him if he had seen it first. In the same letter, Moses asked Austin to sell him the land closer to Clear Creek for his son-in-law Ritson Morris, who was married to Monroe's sister Minerva. He also wanted to buy land for Dr. Heard, the only member of the Texas/Nashville Association to move with him. Both pieces were nicer than the property where he settled. To complete the paperwork and discussions, Moses said Monroe would go to San Felipe to discuss the purchases with him. "He can explain to you the situation of this place better than I can by letter at present, as he has traveled all over the land."

With Monroe's help, Austin sold Moses the property north of Clear Lake for Ritson. Another large league was purchased for Dr. Heard.

While Moses was buying property that year, Morgan, Monroe's New Orleans mentor, made an important decision. He had visited Brazoria earlier and decided to move to Texas, too. He told his partner Reed that they needed to shutter the New Orleans business and move into Galveston Bay. While Morgan returned to North Carolina to retrieve his wife and children, Reed was supposed to close shop. Morgan and his family went overland to Anahuac, at the tip of Galveston Bay. When Reed was finished, he put the remaining cargo on their schooner *Exert* and headed to Galveston Bay.

Once he arrived, Morgan didn't remain in Anahuac. He moved the operations and his family farther southwest, near the Edwards leagues. His property was directly above the property Moses bought for Minerva, her husband and Dr. Heard. Moses's leagues were basically the midpoint—Edwards Point—between Morgan's Point and Galveztown.

With a plantation out of the question on his father's league, Monroe worked for Morgan after he opened the Anahuac store. By some accounts, Monroe was important in helping him build a successful business. It seemed Monroe was poised to receive a larger role in Morgan's affairs. He learned how to establish credit and how to buy and sell cotton, a

major commodity in the world economy. He learned how transactions between merchants and buyers occurred. Wilkes's account of Monroe's life states the boy also watched how Mexican politics affected the economy Morgan, his father and the other settlers wanted to build:

> *Things, however, were not so far advanced at the time which claims our more immediate attention, for then every effort was confined to breaking ground and the tough work of establishing an interest. Due to extraordinary efforts and unremitting attention Mr. Morgan at length secured that foothold in business which indicated his future prosperity to be secure, and Munroe [sic], whose efforts and intelligence had contributed so largely to this state of things had the satisfaction also to perceive that hope of an in interest in the concern, which had pretty steadily possessed his mind for months, approach almost to a practical proximity.*

Not only had Morgan chosen good help, but he had also chosen a prime location:

> *Mr. Morgan had selected for the location of his store and farm, or plantation, as it has since become by the introduction of slaves and the cultivation of slave products, a site on the left bank of San Jacinto bay, a branch of the bay of Galveston, which receives the waters of the Buffalo and San Jacinto rivers. The situation was most eligible, as well for the transaction of business as the operation of agriculture.*

The house he built was impressive and breathtaking: "In due time the store was built, and the residence, which, without ostentation, might be called a 'mansion,' in a few months afterwards took possession of the summit of the hill."

From the east door, a person could see Morgan's wearing ship, the slanting clipper and the dancing cockboat floating in the bay. Decades later, in 1848, parts of the plantation were still reported to be seen:

> *There still the mansion stands with its spotless sides and palings, surrounded with numerous outhouses and negro cottages that mark the nucleus of an extended glebe. The grounds evince the highest state of cultivation, while the rare and precise order of its garden betray the refined care, which at some early period it must have received from a tasteful female hand.*

Morgan created for himself and his family a lifestyle that impressed Monroe. The lad thought one of Morgan's daughters, Mamie, was just as impressive. Wilkes believed her presence was one reason Monroe maintained a relationship with Morgan:

> *There was one other motive that inclined him to this conclusion, and which, though unseen by other eyes had doubtless more influence than all—It was the growing attachment for Mr. Morgan's daughter, who though still a mere child, had already won a stronghold on his feelings.*

Monroe didn't marry Morgan's daughter. Instead, he was more interested in helping the family rebuild after his father's disappointing experience with the Nashville Grant. It seemed everyone was winning in Texas except the Edwardses.

7

IMPERIOUS ROOTS

In 1827, about two years after the Edwards brothers concocted the Fredonian Rebellion, the government sent word that Poinsett should reenter negotiations to buy Texas from Mexico. The basis for the negotiation was the sheer amount of United States immigrants who were living there. In the view of some of the strongest United States leadership, to continue settling Texas with both nationalities would be futile. It was unrealistic to expect U.S. citizens to live with the "ancient inhabitants of Mexico." The cultures were far too different, and the people would never assimilate.

A gentleman from the Edwards family neighborhood, House representative Henry Clay of Kentucky said to Poinsett on March 25, 1827, "These collisions may insensibly enlist the sympathies and feelings of the two republics, and lead to misunderstandings."

Clay kept a conversation going with Poinsett for many years about the undeniable need to purchase Texas. The Kentuckian was convinced it was the best answer. Poinsett was given authority to offer $1 million for the land up to the Rio Grande. If he couldn't accomplish that, he should offer half a million for everything east of the Colorado River.

Both offers were rejected. Within months, Mexico passed a resolution stating that it would not consider any treaty with the United States until it agreed to the boundary spelled out in its original treaty with Spain. That kept negotiations at a standstill since the United States claimed that line was never finalized. Nonetheless, in 1828, Mexico appointed General Manuel de Mier y Terán to run a line that it said was stated in the treaty.

In response, Poinsett was told in 1829 to offer to buy Tejas again. He was told to offer $4 million for the territory east of the line that divides the waters of the Rio Grande and the Nueces. If that failed, he was told to make an offer on the land east of Lavaca. If that failed, he should try to purchase the land east of the Colorado River. If that, too, failed, his last attempt should be to buy the land east of the Brazos River.

They all failed, and Representative Clay was proven right. There would be no assimilation.

WHEN THE EDWARDS BROTHERS arrived in the new republic, the Mexican government tried to collect taxes at the Galveztown Port. Only a few years into their new lives, colonists saw the move as a broken promise. They had been told all their goods would have free port entry. Now, Galveztown had a Mexican customhouse. A customhouse had been built of logs, situated at the foot of Twelfth Street. Customs guards were working at the island and at Velasco in Brazoria. George Fisher, a Serbian who became a naturalized Mexican, was appointed as the customs officer because he could speak good English. His presence at Galveztown and Brazoria irritated the settlers. During the next two years, the amount of business the port saw expanded so much that General Terán came to the island to try to smooth relations with the island settlers. It didn't work.

The following year, a storm swept the Gulf and wiped out many of the 1823 Galveztown settlers who had arrived just a year earlier. More than one hundred immigrants had sailed on the *Revenge* and *Only Son*. The settlers were scattered along the coastline in Galveston, Brazoria and Matagorda. That didn't stop the growth. The island had a deep, rich history with tenacious, rebellious and determined opportunists. Explorer La Salle named Galveston Island in honor of the French King "San Louis." It was a name that would echo through the island's community history for hundreds of years. In 1821, New Orleans newspapers still referred to it as the San Louis. When the land was under Spanish rule, the Spaniards called the island by a more functional term: *Culebra*, or Snake Island. The term referred to the thousands upon thousands of snakes that infested it. Its sister island to the west was Little Culebra.

In 1819, Lafitte gave the island the name it retained. He named his settlement Galveztown and renamed Little Culebra by the name Campeachy. The name Galveztown was not a direct reference to Bernardo de Gálvez, the Mexican governor. Instead, it referred to the town in the territory of Gálvez that does honor him. Lafitte arrived on the island after

the Battle of New Orleans and receiving a United States government pardon for pirating. The pardon was to honor his great efforts to protect the country in the War of 1812. The fact that his magnanimous work was a calculated business move didn't bother the government.

When Lafitte arrived in 1817, he was acting as a spy for the Spanish in the Mexican War of Independence. The island was a favored spot for Mexican revolutionaries, and two were occupying it when he settled down.

Within two weeks, they were both gone, and he rebuilt the island for Spain. He wrestled Indians and snakes. He even tussled with the Nacogdoches filibuster James Long, who was occupying Bolivar and wanted Lafitte to join him. Lafitte had no interest. The privateer also kicked French pirate Louis-Michel Aury off the island. Within a short period, the buccaneer built two hundred new structures and had a town that could easily muster a population of one thousand. Galveztown was much like Lafitte's former smuggling port on Barataria Bay in Louisiana. Essentially, it was an island protecting a mainland. He worked on the bay side and built a headquarters called Maison Rouge. He preferred, however, to do most of his work on his boat, the *Pride*.

He and Jim Bowie set up a repeat operation of their New Orleans racket but with easier navigation. The island, with its natural bay and harbor, was close to the shipping lanes in the Gulf and to the ports in Cuba, which meant human trafficking could be done quickly. Its natural characteristics also made it a favorite for the black market industry. The island is made of limestone, clay and sand that rise only a few feet from the coastline. For seafarers not used to its form, it can look like a series of islands that are jagged. In the 1800s, some parts of the island did not even emerge from the water. Those same characteristics were used by the locals who could move in and out with ease. The entire coast featured rivers that allowed slavers to navigate upstream for miles. The *Brazos*, the *Sabine*, the *San Jacinto* and the *San Bernard* were all used to deliver slaves.

This, however was not the island that Monroe would know. He and his family arrived in Texas after the swashbuckling battles. The buccaneer Lafitte had left years earlier on a dark night after he burned his fort to the ground, leaving nothing but the scorched foundation of his headquarters. Long was killed in Mexico. Aury had hoisted his sails and returned to Florida.

What they left behind was one hell of a town. Treasure-seekers, smugglers, pirates and Indians were marauding a snake-infested, nondescript stretch of hurricane-prone sandbar. The settlers could tell when a bad storm was coming. They watched the snakes scurry en masse to higher ground before

the first drop of rain. None of the stories about the island's current state reached Kentucky. Instead, Moses and others from the North heard about the prosperous future in the New Republic of Mexico.

Tejas offered hope to the enterprising, adventuring and desperate. It had fertile soil, vast resources and a burgeoning colony. It was an alluring story about a land that bordered Arkansas and Louisiana. It was no wonder Moses and Haden wanted to settle it.

Make no mistake, however: the remnants of the buccaneer years were still strong. When Lafitte left, he wanted to shut down his entire operation, but some of his men didn't want to. In the years after he sailed away, these renegades became lone pirates and worked the waters around the island. A few of Lafitte's vessels also remained behind. The *Roach* still made its headquarters there. The United States government seized another vessel he left behind. The Karankawa Indians, who were known to eat people of "dark flesh," were still roaming the area, and new immigrants encountered them. They survived to tell the tale.

The growing presence of the white man forced the Indians east toward the San Antonio River, and they soon left the island. Notwithstanding the Indians, the alluring stories of prosperity were replaced with real work. Like Moses on the Galveston Bay mainland, many people were living in tents:

> *Outside of logs, driftwood and wreckage, cast up by the sea, there was no material for man to build with. There was no clay, timber or stone. In later years brick were made from some clay found down the island, but whilst they were used, they were so soft as to break easily. The old county jail was built from this brick, and the prisoners dug through the wall with their tableware. The old settlers having to contend with snakes, storms, lack of drinkable water, likewise lived in dread of invasion, first by Indians, and later by Mexicans.*

None of that mattered to the United States government. Given the opportunity Tejas presented to its people, leaders wanted whatever the territory had.

Galveztown was sensitive to Mexico's politics. The little island colony was growing fast, with sections of a town beginning to appear. Tensions brewed between colonists and the Mexican government in the burgeoning lands. The year Morgan opened shop at the tip of the bay, he saw custom guards seize the schooner *Canon* in Galveztown. He saw another customhouse built in Saccarap, a section of the island where a small colony of traders, squatters

and U.S. fugitives lived. When Morgan's partner, Reed, sailed their schooner into the bay loaded with goods from their New Orleans store, Morgan seethed when it was levied a tax. He protested and joined the dissidents.

The new independent Mexico was losing patience with the growing number of Tejas settlers and their rebelliousness. Mexico's secretary of state Lucas Alaman stated his new policy toward the United States. He did not like the way the country did business or the way its leaders took over Mexican territory:

> *They commenced by introducing themselves into the territory which they "covet" upon various pretenses. Then "these colonies grow, set up rights, and bring forward ridiculous pretensions." "Their machinations in the country they wish to acquire are then brought to light by the appearance of explorers" who excite by degrees movements which disturb the political state of the country in dispute.*

Texas, he said, had reached this point. Next, he said, "the diplomatic management commences."

His sentiments were growing among other leading Mexicans. Their views culminated into the most unsettling development for the settlers. A fellow from the Edwards neighborhood in Virginia and Kentucky arrived in Galveston Bay. He built a brand-new Mexican fort. The gentleman who supported Mexico was not welcomed in this new republic.

John Bradburn was born in 1787 in Virginia, where he lived until his family moved to Kentucky when he was twenty-three years old. The family moved to Christian County in 1810. This was just a few days' ride from Danville, where Moses was starting a life for the Edwards family. Penelope was chasing a two-year-old Monroe around the house at the time. It's unclear if Bradburn and Monroe knew each other, but their paths crossed more than once before they collided in a place called Anahuac.

Bradburn's time in Kentucky was brief. Within months, he headed for New Orleans. Once he arrived, he became a third lieutenant in the War of 1812. His unit contained a number of notable Texans. The troops included the slavers Jim and Rezin Bowie and people whom Monroe would have known: Joshua Childs; John Durst; Warren, D.C. and John Hall; John Latham; and William Little. Also during the Battle of New Orleans, his combined unit included an entire company of native-born Mexicans, all of

whom he outranked. His unit arrived in New Orleans on January 8, 1815, the same day Andrew Jackson defeated the British.

Bradburn became part of the Mexican efforts to capture Texas from the Spanish and colonize the land. He gained the trust of Emperor Iturbide and soon became an important conduit for him with rebels, whom Bradburn also supported at one point. Eventually, he became such a trusted adviser to Emperor Iturbide that he was appointed commissioner to Washington, D.C., in 1822. When he returned, he brought news that the United States recognized the independent Mexico. Bradburn eventually became a Mexican citizen, and he was loyal to the country.

His level of clout within the Mexican government was beneficial to the United States. In the early 1800s, businessmen would arrive and ask him to intervene in their affairs on their behalf. Land speculators and the military would seek his favor. His prominence was exemplified when he married María Josefa Hurtado de Mendoza y Caballero de los Olivos. She was a wealthy marquise whose family owned large tracts of land in Zocala in Mexico City. In 1830, he was in Matamoros on leave when Manuel de Mier y Terán arrived. After Bradburn finished his leave, he reported to Terán, who sent him to Galveston Bay to secure it for the Mexican settlers who were supposed to arrive. When Mexico decided to limit immigrants, it also had a plan to entice Mexico residents to relocate. The plan ultimately failed, but at this point, the government was dedicated to it:

"General Terán issued my instructions which I followed exactly, and which in brief consisted in the establishment of a new community, a village which would be populated largely with native Mexicans, and which would be protected by a fort, [and] charged with carrying into effect the provisions of the Law of April 6, 1830," Bradburn wrote in 1832, when he recounted the events that led to the disturbance at Anahuac. He also said he was obligated to honor "the petitions of already established settlers in the area so that the government could issue titles."

In October of that year, he boarded the *Alabama* packet on the Brazos River. His crew included his quartermaster, Lieutenant Ignacio Dominguez; a sub-lieutenant, Don Juan Maria Pacho; thirty-three soldiers; and eight convict soldiers.

"Above all [the instructions] provided that we deport ourselves in complete harmony with all the colonies, but unfortunately as we will see later on, it was impossible to maintain the friendly relationships so much recommended," he wrote in his report.

It took them six days to reach the northeast part of Galveston Bay near the Trinity River. He was told that when he reached the spot, he could pick whatever place he liked to build a fort, military town and customhouse for General Terán.

He and his fifty men settled at Perry's Point. It was a spot Bradburn already knew. The site was named after Major Henry Perry, a United States citizen who served Mexico when it battled against Spain. Bradburn served with Perry when he was a captain in the Gutiérrez-Magee expedition in 1812. By 1816, Perry had become a major who used the bluff as a winter campsite. In 1830, Bradburn turned the campsite into a Mexican-controlled military base.

Fort Anahuac controlled the settlers' access to East Texas with might. From its bluff, two eighteen-pound guns topped the seven-foot-thick brick walls of the bastion. It had four-foot-thick walls that the adjacent barracks protected. An underground tunnel gave quick access to a nearby powder magazine.

It wasn't the only Mexican fort being built. Mexico was spending $500,000 to enact the law of April 1830. Forts were being manned and constructed throughout the coast. Arroyo de las Vacas, Bexar and San Felipe de Austin all had forts. Two were along the Brazos River, and one was being built in Nacogdoches, where Haden and Benjamin started their ruckus.

If imperious circumstances weren't in Galveston yet, they were about to be.

8

"O. P. Q."

When Senator Edwards abandoned his family in financial ruin and left his many children to divide Westwood among themselves, Moses came to Texas to rebuild the family legacy. The big bets he'd made on Texas did not pay off. He was about fifty-eight years old when he died circa 1832. Within a year or two of his death, Senator Edwards also died. The disinherited son was about ninety years old and living in Missouri at the time. It is unknown if Moses or Monroe ever knew. They received nothing from the the elder's will.

In 1832, Monroe was a grown man. He was dashing, and he had impeccable manners. He spoke well. He had a charming personality that dazzled the Galveston Bay community. On occasion, he sported whiskers that would loop in perfect circles around his cheeks. His hair was curly, and his smile was large. He'd learned how to press his clothes and buy the best suits while he was in New Orleans. It was a habit he maintained in Texas. Never was he unstyled, but he was always unattached. Monroe was not married and did not have any serious romances. That didn't mean he wasn't surrounded by women, both married and unmarried. He was simply preoccupied with raising money to help his mother, Penelope, and family keep the family farm and land. He continued to work with Morgan as a clerk.

When Moses died, the family managed a small farm on the leagues running the shores of what are today Galveston County's San Leon and Texas City communities. The property he purchased for Ritson and Minerva was more fertile than its coastal acreage. Their property was along Clear Creek in

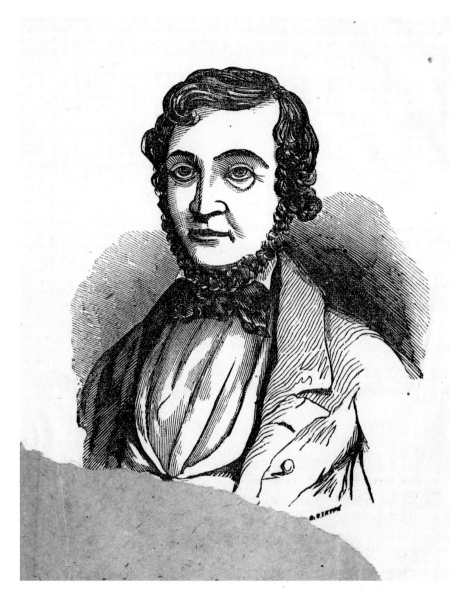

Monroe Edwards at the height of his popularity.

what are now Seabrook and Clear Lake. Penelope had a strong relationship with her children. Monroe was always in touch with her even when he was in Louisiana.

Ashmore, his brother, was a devoted companion. Monroe relied on him and called on him in times of trouble. Being the eldest son, Monroe would

do anything to help his mother and siblings as they struggled to make the lives for themselves that Moses wished for them. Monroe once wrote a poem that pledged his eternal devotion to his mother:

Last night, when sleepless on my bed,
I sighed for the return of morrow
At last soft slumbers sooth'd my head,
And lull'd with fair dreams my sorrow.

I stood in that arcade retreat—
That sweeter spot than any other,
Where by moonlight we are to meet,
And where we'll live and love together—

When rose before my enraptur'd eye,
Yourself; and quick as thought I darted
With open arms towards you; and with a sigh
I wakened; it was a dream—my glory had departed.

There is One, where'er our course we steer,
That o'er our path a radiant blessing flings;
There is a spot to fond remembrance dear,
That to the wanderer's lonely bosom clings.

That one is Mother, who o'er the stormy deep
Of human life, guardian angel smiles,
And as she lulls wild passion's storms to sleep
With dreams of bliss our weary way beguiles.

When the lone exile treads some distant land,
However high his state, or low his doom,
Yet borne by imagination's magic wand,
Memory recalls his mother and his home.

To me more fair than Eden's loveliest bower,
My much loved home; that well remembered scene,
Where the young heart first felt affection's power,
I'll not forget, though years may intervene.

When visions false of wealth or fame allure,
Where rival throngs in eager conflict meet,
Still to his heart returns those feelings pure,
Like tones of distant music calm and sweet.

This poem was written in 1842, after he spent years chasing false visions of wealth. Monroe didn't live on the farm full time. He boarded with Captain Theo Dorsett. Monroe stayed at the captain's home with two lawyers, William Travis and Patrick C. Jack. Travis hoped to gain enough law business to send funds back to his family in Alabama. Jack, also of Alabama, worked with him. The two were attractive and popular just like Monroe. Captain Dorsett most likely met Monroe through his uncles Haden and Benjamin. The captain had led a company for Monroe's uncles during the Fredonian Rebellion. In the years after the fracas, Dorsett was letting the three men room with him and his family. The Dorsett children adored the boarders and were enchanted by them.

Where Monroe had dark, curly hair and occasional whiskers, Travis was tall and had light-colored hair and blue, smiling eyes. He had a good body and broad, wide forehead with a nice rounded chin and mouth. According to some who knew him, Travis was so good looking that it was "like he ought to be a woman." Jack was also good looking, but Travis stood out among the three men.

Morgan found his shop was a gathering spot for the tensions around Galveston Bay and Brazoria. He despised the presence of the Mexican forts and was deeply involved with the settlers' efforts to run their own communities. He never forgot the tax levied on the *Exert* as it entered the bay on its voyage to Anahuac in 1830.

To Morgan, Haden and other Texans, the forts were not offering a warm relationship. They were skeptical of Bradburn's promise that he wanted to keep good relations with the colonists. Behind the scenes, Bradburn's main problem was a testy relationship with a colleague. He wrote about his experience in a later report:

> *A few days after our arrival one civilian, Don Francisco Madero, appeared there as a Commissioner of the State of Coahuila y Texas. This gentleman came in compliance with orders like my own from my superior in the General Government. He, like me, was to grant titles, found a community, name civil officials, etc. Never did Señor Madero explain to me the objectives of his commission although I knew that he was undertaking*

similar responsibilities so like my own, and being convinced that it would be virtually impossible for two Commissioners to perform the same mission, I sent my Adjutant, Dominguez, to politely request a conference with him. But he refused, which led to several very heated communications between us on this subject. However, although complete harmony continued between us, unfavorable rumors spread among the settlers.

Bradburn blamed these rumors for causing dissent. Within days, he was trying to defend himself from them:

There were even those who tried to spread the idea that the General Government did not intend to give them the land on which they were settled and that I would not issue titles. The ill feeling reached such a high pitch that the settlers at Atascosito and San Jacinto armed themselves with the intent to attack me in our newly established community of Anahuac, [and] from which they probably would have been able to oust us since we were barely settled.

According to the settlers, however, they weren't ready to attack him. They wanted to manage their burgeoning town according to the garrison doctor, N.D. Labadie. The doctor was also an undercover rebel and Morgan's friend. The merchant supplied him often with medicine and goods. Labadie said Austin organized a seventy-seven-signature unanimous petition to move community governance forward. No one was organizing an attack.

"The population of the region increased daily and that increase brought with it the necessity of organizing Anahuac into a Court District," wrote Labadie.

Austin's petition called to give the settlers their titles. In exchange, the settlers would quell the unrest that Monroe's uncles created with their messy rebellion. That should be easy since Monroe was also part of the group. Dissent was not only being nurtured among the settlers, but also, in his own camp, Bradburn complained that Madero was working against him. He wanted the two of them to clarify their duties with their superiors. Madero didn't do that. He instead met with the settlers without Bradburn to discuss titles.

While there, Madero watched a group elect Smith's plantation as the county seat. Bradburn was incensed and challenged Madero, which affront he promptly ignored:

A meeting was set for 9 A.M. the following day, but neither he nor his surveyor, José María Carbajal, appeared, so I considered it advisable to bring them to Anahuac. Carbajal, speaking English, promoted discord and absolute disobedience among the colonists. In my opinion, this was the only certain way to insure [sic] tranquility there, and also to protect against an attack on the small military troop under my command. These events resulted in continuing ill feelings towards the General Government by many of the settlers.

At this point, Bradburn blamed most of his problems on Madero. Eventually, he arrested Madero for violating the terms of the law of April 1830. Bradburn was chastised by the Mexican government but not stopped.

At the opening of the congress of the state on January 2, 1832, the governor, in his message, said:

The public tranquility has not been disturbed in any manner in any place in the State, even though Col. Davis Bradburn assumed without the authority of the government the power of arresting a commissioner of the government itself for the distribution of lands.

In response to the settlers' decision to vote on their own county seat, Bradburn sent a fife and drum procession to reinforce Anahuac as the county seat. The settlers were not deterred. They claimed the exaction of duties in the Constitution of 1824 was being violated. Labadie was in a meeting where the matter was discussed:

About the 1ˢᵗ of May 1832, meetings were held at Capt. Dorsett's house relative to the payment of such duties and finally it was resolved that we would form ourselves into a company, privately, for the purpose of resistance to this wrong, but ostensibly for self-protection against the red-skins, or the Comanches, or the Indian tribes generally.

They elected Monroe's friend, Patrick C. Jack, as their captain. Bradburn promptly had Jack arrested and imprisoned him on an American schooner that Mexico had under guard. Bradburn said the only way to control the settlers was to make them obey. The settlers, instead, rallied harder and began trying to get Jack released. After several failed attempts to meet with Bradburn, Labadie went with Judge Robert Williamson, known as "Three-Legged Willie," to meet one last time. Jack was released when Willie

threatened Bradburn with a duel or worse: "I tell you colonel that all hell will not stop me; and Dr L is a witness that what I say is true, and that there are more besides us to make my words good, and that blood will flow if Jack is not released by tomorrow."

Later that day, Jack was released. When he stepped off the schooner, the settlers, which likely included Monroe, presented him with a rusty sword and addressed him as captain. Two lines were formed, and as he walked through them, hats waved in the air and the group erupted in three hearty cheers. Bradburn threatened to punish all of them after he heard about their salutations.

While Jack went back to business, Bradburn moved on to new antics. He sent word shortly after Jack's release that all Texas territory slaves were free and could "go about as they pleased, like white people." Labadie said the reaction was swift: "This caused the owners, who were thus deprived of their own property, to entertain an ill feeling towards Bradburn."

Within days, many Louisiana slaves ran away and headed for Texas. Eventually, three crossed the border and received sanctuary with Bradburn. When the slaves' owner, William Logan, came to the garrison and requested his slaves be returned, Bradburn told him to prove he owned them. Logan returned to Louisiana to get documents and then headed back to Bradburn. In their final meeting, Bradburn said the slaves had requested asylum under the Mexican flag, and he was providing it. He would not release them.

At this point, the community was alarmed. Logan went to Travis for legal advice. Instead of providing advice, Travis took inspiration from the Haden Edwards playbook and concocted a scheme to retrieve the slaves for Logan.

According to Labadie, one dark, rainy night, Travis cloaked himself under a hood and cape. He walked onto the fort and greeted a guard with "Amigo!" He handed the man a letter and left. Bradburn read the letter the next day and became alarmed. It said one hundred men were assembling across the Sabine with the purpose of retrieving the slaves. This letter was a warning from a friend. The name "Billew" was written across the bottom. Bradburn immediately gathered the guards, and the small cavalry was mounted and paraded. The community heard rumors that enemies were a few miles away. A fight was about to take place. Scouts were sent out in succession for the entire day. The next day, all was quiet. It took Bradburn about one week to realize he'd been tricked. He suspected Jack and Travis.

A few days later, while the two men were in their office, thirteen Mexican soldiers appeared and arrested them with no charge. The lawyers were thrown in the calabozo, or jail.

Monroe recalled that Morgan was willing to pledge "every particle of his property he had in the world." Labadie said he also offered goods and money as bail for their release. Monroe said, "All kinds of terms were rejected." Morgan was only able to convince Bradburn to allow one of his slaves to tend to them. Dorsett was able to secure a contract to feed them. Monroe said they weren't allowed to speak to their friends, so he wrote to them. This situation went on for weeks while the prisoners' fates lingered.

Their fates changed one day during a routine prisoner laundry washing. A guard found a letter in one of the men's clothes. It was addressed to "O.P.Q." It asked O.P.Q. to have a horse ready for them at a certain hour on a Thursday night. Bradburn's angry response to this letter was to renovate the large brick kiln he had used to build Fort Anahuac. The masons and carpenters spent a full week turning it into a prison. Two cannons on either side completed the barracks. When the prison transfer began, the entire garrison was placed at full arms. The cavalry was at the head of a column. A line of sentry stood inside the kiln. Travis and Jack marched with Morgan's slave alongside them.

Labadie stood by the fence and waved hello to Travis. The doctor told him to be of good cheer because help would soon arrive. Labadie did not believe it. He was sure they would stand at a military trial in Mexico and be killed, just as Bradburn ordered. In response, Travis and Jack bowed to him. The dignified, silent response touched Labadie, and he was overcome with emotion.

Bradburn was determined to find out who O.P.Q. was, and he had several suspects. During his investigation, he organized a grand ball that Labadie realized was a trap. Bradburn planned to arrest his suspects in one place when they didn't expect it. The ball was held on the night Travis and Jack were thrown in the kiln. Labadie, still overcome with emotion, told people that he wasn't going to go. He was afraid he was on the suspect list. He eventually changed his mind: "However, after more mature reflection, I concluded it would be the most prudent policy to go."

He'd decided that too many soldiers and officers appreciated his talents and skills as a doctor to allow anyone to harm him. Morgan, on the other hand, was another story. Around the garrison, word was reaching him that he and two others were going to be arrested during the ball. Monroe's name was not among them. After Labadie told them about the plot, all three men agreed to attend. At all times, two of them would watch the room. Labadie had friendly soldiers working with him to help his friends escape: "Col. Morgan was dancing with my wife, when a soldier gave me the hint to look

out; a wink to the Colonel was enough—he left my wife alone on the floor, gave a leap from the room and was off."

The other suspects followed. Even Labadie busted through the guns and guards to escape with them. After he stopped running, he realized his wife was still inside with the other twenty women who had attended the ball. He went back. The scene was chaotic as Bradburn tried to determine how the men escaped. In the midst of the confusion, Labadie and his wife walked quietly out of a back door under the watchful eyes of friendly soldiers.

A few days later, word reached him that Monroe had come under Bradburn's suspicions. Labadie went to warn Monroe that he was being pinned as O.P.Q. Monroe had just returned from Brazoria, which meant he didn't go to the ball and didn't know about the latest developments. Monroe responded with "imprudent" language, and Labadie told him to stop it and be more careful or he'd be caught. The next night, soldiers surrounded Morgan's store while Monroe was working alone. They arrested him. He managed to convince them to let him put on his clothes properly so that when he arrived, he would still be dapper. He entered the kiln and waited for the reinforcements he'd called for without anyone's knowledge.

MONROE KNEW HE'D EVENTUALLY be nabbed as O.P.Q. On May 24, 1932, Monroe wrote to "Three-Legged Willie" to alert him that he needed to rally the settlers because he could not. He told Willie about the O.P.Q. letter: "An investigation is now going on and I am strongly suspicious they can produce no evidence against me but I have no doubt that I shall be a tenant of the Calibozo before 10 October arrives."

He writes as though he didn't know the mechanics of Travis's plan to trick Bradburn. He said D.C. Hall had started the rumors about an army marching to rescue the slaves. Monroe believes that Hall's rumors landed Travis in jail after a "creature named McLaughlin, a sycophant of Bradburn's" gave the leader a letter. That letter pinned the entire incident on Travis. Monroe writes that Jack was not actually arrested but went willingly to the fort. Jack wanted to find out why Travis was being arrested:

> Our mutual friend P.C. Jack being anxious to see what they intended to do with Travis went with him to Bradburn's quarters where they had an interview. Some words past [sic] between Bradburn and themselves and he ordered them to the Calibozo forthwith.

According to Monroe, Travis and Jack weren't going to be allowed to defend themselves when they went to the Mexican court. Monroe didn't advise Willie on what to do. He just wanted him to rally Austin's Colony to "help" get the men released. Monroe worried that Bradburn was building a case against his friends that didn't depend on the truth: "All sorts of villainy has been practiced to obtain testimony against them & Bradburn has even gone so far as to put a poor drunken vaggabond [*sic*] in prison because he woult [wouldn't] sware [*sic*] what he wanted him to."

Monroe was loyal to his friends and steadfastly believed they were innocent. He said he was prepared to face whatever fate had for him as "O.P.Q.":

> *I have been advised by my friends to leave hear* [sic] *but feeling concious* [sic] *that I have done nothing but my duty I will not run off let the result of conciquences* [sic] *be what they may. I wish you to communicate the substance of this letter to the friends of Travis & Jack and act as your feelings may dictate.*

Willie received the letter. His feelings dictated that Austin's Colony should go to battle.

9

KILN AND CANNON

Anahuac was one of the worst experiences of Monroe's life. He never discussed details, but years later he would say that because he survived the prison kiln, he could survive anything.

When Willie received Monroe's letter, he spread the word about his friends' fate. As a result, Judge Jack Travis forced Bradburn to let him see his brother. After their visit was finished, the settlers followed Judge Jack back to his boat. As he left, he told them he would return in a few weeks with more of Austin's Colony. With that, several of the settlers tried to convince Bradburn to let civil authorities try the prisoners. In exchange, they promised to follow whatever the trial found. He refused.

"All of our treaties were unraveling," Labadie wrote.

In fact, Bradburn now had a total of seventeen prisoners in the kiln. One of them was Monroe's brother-in-law, Ritson Morris, nicknamed "Jaw Bone." He bribed his way out by giving a guard an empty wallet. Ritson told him to go to a certain man—perhaps Monroe's brother Ashmore or Dr. Heard—and tell him to give him ten dollars. That money would be his payment to let Ritson escape. The guard did it, and Ritson walked out.

In June, Austin's cousin John and his friends led a band of 90 men from Austin's Colony to Liberty. Once there, the "Liberty boys, who are always on hand for an emergency," joined them. They now had 130 men ready to march on Anahuac. They stopped on the north side of Turtle Bayou, where they sent out seven scouts. The scouts were making their way through a skirt of timber when they saw, in an open prairie, several

of Bradburn's Cavalry. Since they hadn't been seen, they tied their horses, took their rifles and charged on foot. They captured 19 of the cavalry. The next day, the crowd walked into Anahuac at high noon and demanded the release of the prisoners.

Bradburn sent Colonel Souverin, a Santa Anna supporter, to negotiate. Souverin was sent to Anahuac as a political prisoner. He traveled from the Rio Grande on the schooner *Martha* a few days before the crowd marched. When Souverin heard of the situation around camp, he offered to help. Bradburn let him.

Souverin negotiated with John Austin, D.C. Hall, Colonel Martin, William Jack and some others. They agreed that the crowd would move six miles from Anahuac. After they did, they would return Bradburn's cavalry in exchange for the prisoners. Once the negotiations were settled, the men returned to the crowd and put the agreement to a vote. Agreeing settlers were told to shoulder their rifles. Ritson, who knew the conditions Monroe and the others were in, left his shoulders bare. Labadie was the only other to join him.

Labadie said he and Ritson were "begging the men to consider the risk we would run by giving up our prisoners first; and we urged that the exchange should be made at the same time."

Their words fell on deaf ears. Everyone went home and left the Anahuac settlers and John Austin to give the cavalry back to Bradburn.

At 9:00 p.m., Bradburn's guards lit eight fires. A guard came forward to talk to Labadie while the rest of the guards carried off the ammunition, belongings and clothes the crowd had waiting for their friends. The guard told Labadie that Monroe and the prisoners were not going to be as heavily guarded anymore, but Bradburn was not going to release them. The guards took the cavalry and finished. They extinguished the fires at about midnight and left.

Before the meeting, Bradburn told a guard to give a letter to John Austin. At six o' clock in the morning, he went to Labadie to show it to him. Bradburn wrote that the treaty was broken, and he was prepared to pillage the residents and take the property of all the settlers regardless of whether they were involved with the rebels. The men got on their horses and, at a gallop, rode to find the group that had left the night before.

They found them at Turtle Bayou, where Labadie read the letter. They signed a resolution to support Santa Anna and declared H.B. Johnson as alcalde. Within hours, sixty men were ready to ride to defend the settlement. They put their horses at Labadie's property and positioned themselves for a

fight. Bradburn approached with a four-pound cannon, and fear set in. The women and children began to run around trying to get away from its reach.

Dorsett loaded his women and children into a cart and headed for Labadie's but decided they were worse off there. As he sped off to safety, his wife and older children cried to Mrs. Labadie, "Run, run or you'll be killed!" The settlers tried to retreat, but by the time they did, Bradburn's forces were between them and their horses. A skirmish ensued after one settler said he would not retreat and fired on the troops. He and up to fifteen others were taken prisoner.

In the mayhem, the remaining men, women and children scattered. They found their way farther north and ended their run at James Taylor White's house. White had been giving food and supplies to the battling settlers free of charge for a while now. Once they calmed and regrouped, they made a decision: they needed a cannon.

Anahuac was escalating from prisoner release to full battle. The plan was now a territory-wide effort to secure freedom for Monroe, Travis, Jack and whoever else had ended up in the kiln prison.

In Brazoria, a three-pound cannon was in the area. John Austin had a schooner and offered to haul the cannon to Double Bayou. As he did, Bradburn got word of it and instructed Ugartachea, who commanded the Velasco fort, to stop him. Three-Legged Willie began telling the crowd at Turtle Bayou that Austin and the Velasco residents were going to fight Ugartachea to get the cannon through. Labadie was tending to the hurt settlers at Turtle Bayou when he and the others started to hear guns and cannons coming from Velasco. When it stopped, John Austin and the settlers prevailed. The cannon passed.

Colonel Piedras heard about the matter and headed to find out what was causing all these skirmishes. Without his soldiers, he came within a mile of Taylor White's and spoke to the crowd. He promised that if the release of the prisoners was the cause of all this commotion, he would release them all. Piedras did just that within days.

He also arrested Bradburn. Even under custody, Bradburn got a guard to stay with him because he feared Travis, who was vehemently angry, was going to kill him. Piedras sent Bradburn to New Orleans, where residents were so angered by his actions in Texas that he had to plead for peace in the newspaper. The Mexican consul found him a safe vessel and sent him on to Vera Cruz. His career never recovered from the antics at Anahuac.

The disturbance at Anahuac, a precursor to the Texas Revolution.

Travis never attacked Bradburn. He just went home. Once the three friends were released, they went to Dorsett's house, where they surprised everyone. One of Dorsett's daughters, Amanda, was the first to see them walking to the house. She was jubilant at the sight of them. "Oh, Mamma! Yonder comes Mr. Travis and Mr. Jack and Mr. Edwards!"

Mrs. Dorsett didn't believe her because word of the release of the prisoners had not made it through the settlements yet. She told her daughter to hush. In a few moments, the three men arrived at the door, where they were warmly welcomed. They ate their first real meal in months with the Dorsett family. The men stayed with the captain afterward but not for long. Within days, William Jack came for Patrick. They left for the Brazos and never returned. Travis left with another group and headed west. Monroe was the only one who stayed. He remained near his family and kept working for Morgan.

Monroe would never see Travis again. When he saw Jack again, it would not be a happy reunion.

10

LOMBOKO

One day, as Monroe was running errands for Morgan's store in Galveston, he ran into an unexpected friend he'd known in New Orleans. A slaver named Holcroft had a deal for Monroe in the "black diamond" trade, a romanticized term for the slave industry used in the 1800s.

In 1832, Britain was one year away from abolishing slavery completely. The Transatlantic Slave Route was an eighteen-month journey that connected goods and slaves all over the Atlantic Ocean. In Africa, slavers exchanged European goods for slaves to work the United States' southern plantations. Europe had a great need for the cash crops that slaves raised and harvested for plantation owners. The crops were hauled over there for sale. While in Europe, the slaver and traders bought more European goods for the African leg of the journey. Along each step, profits were reaped. A commitment to work this route was a way to get wealthy quickly, albeit at great risk.

To Monroe, it may have seemed a way to help his mother keep the family leagues. With the route about to be disrupted by abolitionists, it was perhaps his last chance to get involved.

Morgan was not happy with Monroe's decision and told him he'd do better to stay with him longer. Monroe, though, had made up his mind. He left his family and Morgan for an adventure and the lure of fast, hefty profits through the sale of human cargo. The decision would change his future.

Monroe's entire life had been eclipsed by the world's attempts to end slavery. In 1807, the year before he was born, Britain's abolitionist movement began to take hold, and the country passed its first law to prohibit slave

trade on the open seas. The following year, the United States adopted a law prohibiting the importation of slaves. But the laws all had loopholes, as Monroe learned in New Orleans. He may have thought that even if another British law loomed, he could find a way around it, especially in the upheaval Texas was under.

Until Anahuac, Monroe's uncles had instigated one of the bitterest events between the American colonists and Mexico. The Fredonian Rebellion revealed the culture clashes, language barriers, political wrangling and economic stress both groups were enduring. The issue of slavery notwithstanding, the climate was prime for a quixotic businessman to seek wealth, especially if he sailed from the Texas coast. The convergence of so many layers of economic and political unrest gave slavers an opportunity to create a smuggling network.

Even if Mexico overlooked the fact that Texas settlers were bringing their own slaves overland from the United States, it had maritime laws prohibiting slavery. In 1824, the Mexican congress declared that any vessel that had slaves on it would lose its cargo. The owner, purchaser, captain, master and pilot would be imprisoned for one year. Slaves would be freed "the minute they touched Mexican soil."

The antislavery sentiment of Mexico presented Texas with an uncertain future. Reeling from the fall of Iturbide in the 1820s and '30s, the country was preparing to address Texas's need for slaves. In the United States, this uncertain status about slavery became a problem in attracting colonists. Cotton could be raised on a small farm, but to reach the scale and size needed for the world trade route, slaves—and a lot of them—were necessary. If someone could ensure that slaves would be available on a regular basis, he could become wealthy in a very short time. The result was a black market for the importation of slaves. The economy demanded its existence.

Competition inside the Texas slave industry itself was not great, since most of the colonists brought their own. Only a handful of slavers brought Africans through the Texas ports in the 1830s. Joining Bowie were men like James Merrill, Samuel May Williams, Richard Royall, Sterling and Pleasant McNeil, James W. Fannin Jr., David Byrdie Mitchell, John A. Quitman, Beverly Chew and Nathaniel Gordon. They exploited explosive political tensions to supply the settlers' economic demands.

In the 1830s, Texas was poised to become the New South with vast plantations of cotton. Austin and others thought that, over time, Texas could become a direct rival of the United States. Britain was eager to support Texas because southern U.S. plantation cotton was prized. In fact, for several years,

Britain often overlooked the politics of slavery to support Texas as a prime exporter. Britain knew a vast supply of slaves was critical to the creation of a plantation economy.

Texas slavers purchased in the Cuban market, where a direct network had been established to provide African slaves to the island market. A slave sold for $300 or $400 in Havana. With the high demand in Texas, the slaves could be resold for $1,500 per person. A trip directly to Africa, however, was even more lucrative. Through his friend Holcroft, probably an alias, Monroe became one of the few Texas slavers who would make the transatlantic trip. Holcroft was a thirty-five-year-old slaver who worked between Africa and South America on a regular basis.

In Brazil, slaving was a solid occupation. It was politically safe and financially profitable for the white slaver as long as he didn't encounter the Royal Navy. Holcroft had, and now he wanted Monroe to help him circumvent Her Majesty's vessels on future African runs. According to one journalist's account, Monroe had no idea why his friend had shown up in Galveston:

> *He cast his eyes rapidly over the tall figure of the corner, but though he was baffled for a moment by the heavy scar which ran transversely across both the stranger's lips—the bronzed cheek, the jetty locks and the strong lineaments which met his eyes, identified the slaver.*

They spent time catching up on news and each other's lives before Holcroft made his offer. Monroe, having been raised alongside a family of opportunists, couldn't say no: "He adopted the maxim that the world owed every good fellow a good living, and very soon came to think also, that it mattered very little how a good fellow got it, provided he could keep himself clear of the interference of the law."

Holcroft was the captain of the *Clara*, a slave ship owned by Brazilian slave merchants. During his last excursion, the British had boarded the ship and caught Holcroft with a cargo of slaves. He surrendered, and his crew left the *Clara* at night on rowboats near the shore. To rectify this situation on future trips, Holcroft told the merchants he would hire a second slave captain. This second captain, or "fly captain," would come in handy if they were ever stopped again. He told them he would find an American man who would do the job. That man was Monroe.

Slavers had many ways to circumvent the Royal Navy, which patrolled the waters looking for slave ships. The worst way was to simply fly a false flag. That rarely worked because, once boarded, officers would discover the

true registry. Another was to forge a set of papers, but this was also a roll of the dice. The captain could be made. A third option was to bribe a corrupt official into making a second set of papers. Given that Monroe would have had to know the exact corrupt official to bribe, it is doubtful he did that.

He was more likely hired to help Holcroft trick a port official or counsel into giving them legitimate papers. There were a couple ways to do that, and all required some advanced skill in smooth deception. A fairly secure scheme that would have relied on Monroe's impeccable gentlemanly manners and presence could have sparked Holcroft's interest. Monroe could have gone to the Brazil consul in the United States and obtained brand-new registry papers. These papers would have been hidden until the ship left U.S. territory. He could have done that but probably didn't.

The most likely scheme would have required Monroe to forge the bill of sale, which he was quite capable of doing. Then he would have taken it to the U.S. port and registered the ship. The true papers would never have been shown. Whatever method was used, the two captains would have had to watch for government ships the entire time they sailed. Depending on the situation, they would show either U.S. or Brazilian papers and hoist the appropriate flag.

Early on during the abolition movement, U.S. ships were always less suspect for slaving than those belonging to any other country. A South American ship was far more suspect. If the British were spotted, the crew would hoist the U.S. flag. If the Brits boarded the vessel, Monroe would handle them. If he completed the trip, he would earn between $5,000 and $8,000. Dual flags were a problem for the United States. Within a decade, President Martin Van Buren would try to stop the practice, but Congress didn't have enough consensus to put muscle behind his request. In time, almost every slave ship on the African coast would fly the U.S. flag under false pretenses.

As it turned out, the Royal Navy was the least of Monroe's problems.

The two captains sailed from New Orleans to Rio de Janeiro, where they launched the *Clara*. The seas were calm and tranquil for ten days before the weather turned. A dark storm entered their path. Monroe blew the trumpet, and the crew headed downstairs. Holcroft grabbed Monroe's arm to drag him below. Their grasp slipped. Monroe was scooped into a wave and flipped overboard. Once he reached the surface, he struggled and gasped for air. When he began swimming, his hand landed on a wooden plank. He held on for two days until a passing ship rescued him.

Once he recovered, Monroe told the rescuing crew that he belonged to a wealthy family in Louisiana and was headed to London. He told them that

THE STORM IN THE GULF.

Right: The sea storm that swept Monroe overboard.

Below: The British Navy leaves the slave ship.

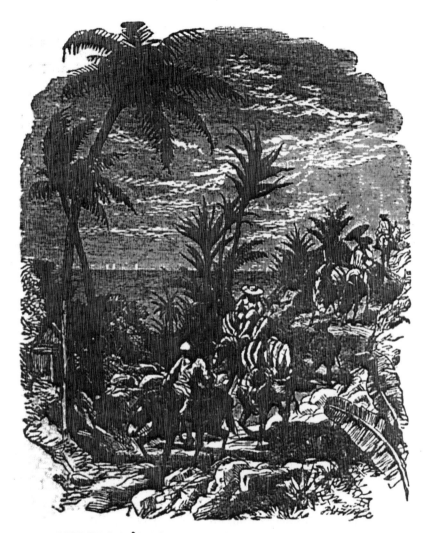

HOLCROFT'S SOUTH AMERICAN PLANTATION.

story rather than the truth—that he was from a struggling family in Texas and hoped a slave run would get money for them. Once they docked in London, the captain helped him obtain a loan for his return to Brazil.

When he arrived in South America, he spent several weeks looking for Holcroft. When he found his friend, the slaver was unemployed. The ship was gone, and one of the partners who had hired him had died. He was now

in debt. Monroe was concerned they wouldn't get any more jobs. Holcroft convinced him that the cotton production in the South was too productive to do without slaves. They'd find work.

Within a short time, a new slave broker, who called himself Signor Saleria, hired Holcroft for $20,000. Saleria took slave orders from the plantation owners and then hired a slave captain like Holcroft to go to Africa to fulfill the order. With money from Saleria, Holcroft purchased a new slave ship for $2,500 and spent $150 on repairs. Monroe was paid $5,000 to be the fly captain of the new *Clara*. His alias was Captain Jones. They used the same papers under the same scheme they had used before. A few weeks after they sailed, they were chased and boarded by a British cutter. Just as the plan stated, Holcroft pretended to be a deckhand, and Monroe acted as captain. A journalist recounted the moment:

> *The lieutenant in command, rather pleased with the politeness and prepossessing manners of Captain Jones, proceeded with him to the cabin, and after a very cursory examination of the papers, and a few questions as to what news he brought with him from Rio, returned again to the deck. He looked at a few hatches and gave a few side glances to the crew and then, bade the young Yankee skipper and his whiskers good morning and pulled back the cutter.*

The next day, they sailed near Cape Palmas, which Maryland abolitionists were colonizing with a plan to allow free Africans to return to their homeland. They turned the *Clara* away from the cape and headed northwest until they reached one of the Lomboko slave stations. Several Kroos (the middlemen who helped the slave ships and their captains) saw the *Clara* pull up; as many as sixty-three slave ships at a time could be waiting for Lomboko cargoes during the 1830s. For their assistance, the Kroos tribe was supposed to receive slave immunity, although in later years, Kroos were found on slave ships. In case the Royal Navy was nearby, the Kroos would pretend to be bringing the weary travelers fruits and other refreshments. Traveling in Africa exposed the horror of the slave trade. The Monrovia tribes had fierce and atrocious conflicts that horrified abolitionists trying to break the cycle. The tribes were involved in cannibalism, and when towns were captured, as many as thirty victims could be sacrificed. An abolitionist from Cape Palmas wrote that the situation was instigated by the slave traders: "This trade is the fruitful parent of savage wars and of cruelties and sufferings surpassing the boundaries of the human imagination."

The Kroos guided the crew three hundred miles up the river to the fortress itself. Once they arrived, Holcroft chose two or three of them to help him during his stay. The rest took care of the ship.

Lomboko, on the Gallinas coast in Sierra Leone, dated to 1814 when John Faber moved there to circumvent the Royal Navy ships cruising the west coast of Africa for slave ships. It was one of two major slave markets operating off the Gallinas River. An estimated two thousand slaves were moved from there each year. Havana merchants hired Faber to create a supply of slaves for them from Sierra Leone. When he retired, he left Lomboko to Pedro Blanco, who used it to become so wealthy that New York bankers were pleased to have his business. Faber left Blanco with a large network of chiefs who kept Lomboko stuffed with slaves within its 120-foot-high walls. Blanco's reach was so vast that he had to have agents in various spots along the islands at the mouth of the Gallinas River. The fortress had several large depots, or barracoons, for the war prisoners captured in tribal battles. Lomboko also had palatial buildings for its slave operator, his concubines and his employees.

When Monroe was at the fortress, it was the most active time in its history. From 1824 to 1839, between 80,000 and 100,000 slaves were shipped out of the Gallinas to Cuba. Dozens of slave markets stretched from Cape Mesurado to the west of Sierra Leone in 1834. The Gallinas supplied the Cuban market until 1846. During that time, the Royal Navy captured a scant twenty-three ships that carried an astonishing total of 51,000 slaves. Approximately 48 percent were children and infants. Only three of the twenty-three ships were not heading to Cuba. Abolitionists were aware that the new Texas slave market had much to do with the explosive growth of the Lomboko network. In 1823, one abolitionist working in the region predicted the wave:

> *There is a reason to apprehend that African slaves will be illicitly introduced through the Havana into Texas, and rumors exist that agents from that country, and even commercial houses in the United States are disposed to enter into arrangements for that purpose.*

Within five days of their arrival, Monroe and Holcroft chose 198 men and women. The Africans were young, robust and mature. The purchase cost averaged twenty-five dollars each person—much cheaper than after the boat made the long Middle Passage.

Holcroft and Monroe paid with what was described as "a superload." They had muskets, powder, rum, cutlasses, bar iron and tobacco. By

THE SLAVER LYING OFF THE AFRICAN GOLD COAST.

the time they arrived in Brazil, eleven people had died, and one man, the son of a chief, committed suicide by jumping overboard with his arms crossed. He was a strong, muscular man whom Monroe recalled as having a "manly sadness." He would talk about the suicide as "a strange

Monroe and Holcroft likely burned their slave ship.

and peculiar incident." It is very likely that after they delivered the slaves, they burned the ship.

Monroe was now considered the wealthiest man in Texas. He and Holcroft had $100,000 in profits between them, and they weren't finished yet.

11

BEASTLY

Monroe looked the part of one of Texas's most prominent and substantial men. His good looks and manner were refined after his trip. Standing five feet, nine inches tall, he was elegant and always had a better style that set him apart from the "rudeness of society." He developed a quiet intelligence marked by shrewd self-possession. He spoke in "high opinions" and did not have a blemish on his character. It is almost like he was a Lafitte for the 1830s—a gentleman slaver.

A few saw him as the personification of the nouveau riche. One girl who watched him one night as he ate an enormous amount of sweet potatoes said he had a rich and gaudy attire. He wore flashing diamonds. His horse was "gaily caparisoned" with silver spurs and a silver-trimmed saddle and bridle. Money was buying him the lifestyle his father always wanted him to have.

After his African slave run with Holcroft, Monroe used the profits to fund other ventures. He obtained land grants from Mexico for acreage in Nacogdoches and San Augustine. The land was near the leagues his uncle Haden had lost years earlier. In Galveston, Monroe purchased saloons and gambling dens inside the Saccarpo section of the island.

In the fall of 1833, he and Holcroft made a Cuban slave run. They sailed into Galveston Bay to Edwards Point, where they landed the slaves. Each person sold for $600. The men split another $100,000 profit. A year later, settlers claimed they knew Monroe had been landing slaves in Mississippi and Louisiana. It's unclear if Holcroft helped him in that run, but Monroe ended up being arrested. The legal issue seems to have been short-lived

because he was running enough slaves after 1834 that people knew him as a slave smuggler. They didn't think less of him for it. In fact, Benjamin F. Smith landed slaves at Monroe's home in Edwards Point in 1833–34. A year later, Morgan also investigated the chances of becoming a slave smuggler through the New Washington Association, which he started with New York investors. It fell through when an agent couldn't broker a deal with Bermuda, which scoffed at them. There were only a few Texas slave smugglers, and they were all considered "good" citizens.

Monroe's brother Ashmore was also providing well for the family. During the time Monroe was gone, he had turned the farm and land around. The Edwards leagues were making money, probably through cattle, and the family was once again prosperous. Between 1834 and 1835, they sold their estate at Red Fish Bar. Monroe took care of his family around this time, and they lived with him. His attraction to one of Morgan's daughters, Mamie, also blossomed again, but the timing wasn't right and nothing ever came of it. By the end of 1835, Monroe's mother and one of his sisters had decided to move to Natchez, Mississippi. Monroe helped them with the move and took the opportunity to do some business on the road.

In New Orleans, Monroe sold forty-eight thousand acres to Thomas Jefferson Green of Florida. Green was a land speculator like Monroe's father and uncles. As the agent for the Tallahassee-Texas Land Company, Green had $80,000 to purchase plantation-quality land along the Brazos, Nueces and Red Rivers so Florida residents could colonize Texas. Monroe sold him tracts along the Red River for $16,000, and once the deal was done, they never met again.

In Mississippi, Monroe met Christopher Dart. Dart was born about 1792 in New London, Connecticut. He was a lawyer and a clerk for the U.S. District Court. The men discussed several possible land deals but none that they could agree on, so Monroe offered a slaving deal. To convince his potential partner, Monroe described how political unrest and disruptive economies in Texas and Cuba could be exploited for financial gain.

After his uncle's Fredonian Rebellion and his own Anahuac incident, Monroe's friends increased pressure on Mexico. Battles and skirmishes occurred often while politics heated up. Morgan, Patrick Jack and Austin convened with other Texans at the Convention of 1832. They issued support for Santa Anna and then began politicking. They drafted resolutions to soften the Immigration Act of 1830. They wanted to build schools that would teach in both Spanish and English. They wanted a commissioner to issue land titles in East Texas. They wanted to prevent white people from encroaching on

Indian lands. Other resolutions were also drafted, but none was ever adopted, and Mexico levied charges that the settlers had conducted an illegal meeting. Austin surmised that they weren't timing their agenda right.

The next year, they gathered again. In the Convention of 1833, they asked for the repeal of the 1830 immigration law. They wanted improved mail service, judicial reform and more protection from the Indians in East Texas. They also wanted a jury trial and other rights granted in the United States. Monroe explained to Dart that none of the resolutions was being adopted, and his friends were about to declare independence.

This would be one of the final chances to run slaves. Monroe had been censured at the convention, and his smuggling efforts were considered piracy. During the event, the delegates discussed Monroe's slave landing at Edwards Point. A strong message was entered that the slaving episode was an abhorrence and no good person should support it. They also beefed up port-patrolling efforts and pledged to seize any slaves found on any ships.

Now a consultation, or rebel government, was underway. They began in November 1835 to prepare for a revolution. If Monroe and Dart were going to get rich off slaving, the run had to happen before Monroe's friends began the revolution. He also told Dart about his Cuban slaving expeditions with Holcroft. A new slave loophole had been created in the British and Spanish colonies. In 1833, Britain put its Caribbean slaves under a "gradual release" freedom program. Slaves were called "apprentices" and would receive their freedom when they "completed their service." By 1840, all Caribbean slaves would be free. Furthermore, England and Spain were diverting captured slave ships to the colonies, where the slaves were also being "apprenticed."

These apprenticed slaves were being sold. The closer the slaves were to reaching their freedom, the cheaper they were selling for. Monroe told Dart that the average slave cost about $200. Monroe wanted to buy at least 200 slaves using the ruse that he was taking them to Trinidad plantations to finish their "apprenticeships." Once purchased, he would bring them to Texas, where he and Dart could move them to Louisiana and make an immense profit. Dart agreed to invest and gave Monroe $52,000, which was enough for about 260 slaves. As collateral, Monroe gave Dart some of his East Texas land deeds.

In December, Monroe got more slaving funds from the George Knight and Co. The company loaned him $35,000 to buy Cuban slaves. It also loaned him $500 to buy a cannon to support his friends in their upcoming revolution. Mariategui, Knight & Co. was the Cuban branch for the British Baring Brothers, a large trading and investing bank in London. The brothers

funded slaving and other projects along the Atlantic trade route. In 1828, they began funding Cuban-based Mariategui, which shipped sugar to the northern United States. The bank also had an important history with the U.S. government. It financed and brokered the government's Louisiana Purchase and its role in the War of 1812.

In 1831, George Knight, an American working for Americans in Havana, visited the family in London. He wanted to discuss new credit tools the bank had for helping merchants in the booming Cuban slave markets. The relationship prospered during the next few years and came to a head when the bank decided to focus squarely on American investments. In specific terms, the British bank wanted to profit from the rich southern plantations, which meant it would, among other investments, make loans for slave smuggling. In 1834, when the brothers wanted to hide their involvement in the Cuban slave trade, they authorized Mariategui, Knight & Co. as their agent. In Texas, the company was known as George Knight & Co., and Monroe was one of the first slave smugglers in whom the company invested.

Later that month, Monroe and Dart arrived in Havana with $50,000 in cash. They began buying slaves for roughly $357 per person. Their total bill was $67,116. Monroe also bought the cannon, jolly boat, gunpowder, balls, peas, grain, beans, bananas and oranges on credit. They left on December 17, and Monroe probably brought the slaves to Texas without Dart. He landed about 183 slaves from the *Shenandoah*. In the same year, he landed another 50 slaves off the *Harriett*. The schooners were used to transfer goods between New Orleans and Texas ports. Monroe used the *Shenandoah* often for slave transfers that ended at Edwards Point or Chenango Plantation in Brazoria, where Ben Smith used it as a slave warehouse, too. Not all of the slaves made it to either warehouse. Monroe lost 124 slaves during the Mexican advance in 1835, which led many people to believe that if a "wild Negro" was found anywhere between the San Bernard River and Galveston Bay, the person was probably one of Monroe's escaped slaves.

The following year, on February 28, 1836, William S. Fischer, the Velasco port collector, watched the *Shenandoah* round the Brazos's mouth. He followed it when the crew failed to report to him. In his March 2 report, he described the event:

> The schooner Shenandoah *entered on the 28 ult. and proceeded up the river, without reporting. I immediately pursued her....We overhauled the vessel that night, and found that the negroes had been landed—the negroes were, however, found during the night. The negroes I have given up to Mr.*

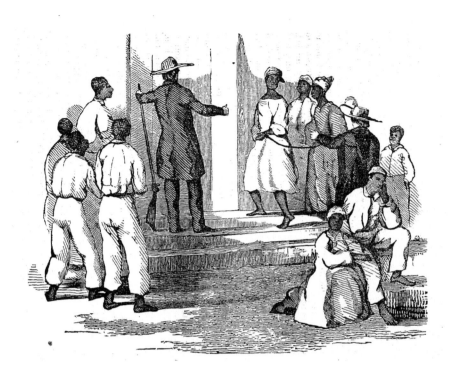

Monroe arrives at Chenango with Cuban slaves smuggled into Texas.

> *Edwards (the owners) on his giving bond and security to the amount of their value, to be held subject to the decision of the government. Sterling McNeil landed a cargo of negroes (Africans) on the coast. I endeavored to seize the vessel, but was unsuccessful—This traffic in African negroes is increasing daily, and as no law has emanated directly from the Council in relation to this matter, I am very much in need of instruction.*

Fischer found 171 slaves, which Monroe claimed. On the day of that report, Monroe's contemporaries signed the Texas Declaration of Independence at the Convention of 1836. Fischer never got any instruction. The Committee on Naval Affairs received the letter and filed it. Fischer was told that his complaints had raised questions that were beyond the committee's scope.

In March, the *Dart* sailed into Galveston Bay with 90 African slaves from Cuba. These were delivered to Ritson Morris, who now had a total of 122 slaves on his property. That month, traveler William Fairfax Gray wrote about his encounters with slaves Monroe had brought to Texas. Gray

was staying at "Mr. Earle's" on the San Bernard River. He described the behavior of the slaves as "beastly":

> *He has staying with him four young African Negroes, two males, two females. They were brought here from the West Indies by a Mr. Monroe Edwards. They are evidently native Africans, for they can speak not a word of English, French or Spanish. They look mild, gentle, docile, and have never been used to labor. They are delicately formed; the females in particular have straight, slender figures, and delicate arms and hands. They have the thick lips and negro features, and although understanding not a word of English, are quick of apprehension; have good ears, and repeat words that are spoken to them with remarkable accuracy.*

The following month, a gale caused him to stop his travels, and his guides took him to Edwards Point. He dined with Ashmore and Ritson and saw Guinea slaves whom Monroe was keeping at the family homestead:

> *Ran into a cove at Clear Creek, and landed at the home of Mr. Edwards, where we found Ashmore Edwards and his brother-in-law Ritson Morris (Jaw Bone M.), a Mr. Aldridge and Mr. Stanley. We were kindly entertained....Mr. Edwards is the nephew of Col. Edwards of Nacogdoches and the brother of Monroe Edwards, who imported Guinea negroes about a month ago.*

While he was there, he spoke to the fifty slaves, whom he described as being treated like cattle.

> *They are all young, the oldest not more than 25, the youngest, perhaps, not more than 10; boys and girls huddled together. They are diminutive, feeble, spare, squalid, nasty and beastly in their habits. Very few exhibit traits of intellect. None seem ever to be accustomed to work. Some of them gave the same names to common things that those I had seen at Edward's did; others gave different names; of course from different tribes.*

He noticed that one girl stayed away from the others and spoke to no one: "She is said to belong from a tribe different than the rest, and to stand on her dignity."

A fifteen-year-old boy was described as a prince, and others deferred to him. He claimed five wives, and he flogged them as he desired. Gray said the children would sing and dance. Some preferred to wear capes and blankets,

while some preferred to be naked. An old American Negro watched over them and whipped them while they ate to keep them from tearing apart the meat: "A beef was killed at Morris' home, 100 yards from Edward's. And the Africans wrangled and fought for the garbage like dogs or vultures; they saved all the blood they could get; in gourds and feed on it."

Numbers for the amount of slaves Texas smugglers traded during 1835 and 1836 range from five hundred to two thousand. Whatever the number, Monroe was in front of the pack.

12
TEXAS, 1836

Events were unfolding in Texas just as Monroe had predicted to Dart. Texas settlers' support for Santa Anna died when he switched his views on federalism. The work Monroe's uncle Haden and his father's partner, Leftwich, had been part of in Mexico was falling apart. Santa Anna dismissed the Constitution of 1824. He also disbanded the local-level authority that Haden and Leftwich had been considered important in creating. While Monroe was traveling between Africa and Cuba, the Mexican government arrested Austin as he left after negotiations. They threw him in a dark dungeon for more than a year and never charged him with any crime. By the time he was released in 1835, Austin had no more pro-Mexican views.

In 1836, fellow slaver James Fannin worked with Dr. John Grant and Frank Johnson to devise an attack on the Mexican government. They would march to Matamoros, where they would invade. All Texan men were being called to battle for the spring campaign.

Monroe's friend William Travis became the commander of the Alamo. He held the title with another slaver, Jim Bowie. While they were trying to hold off the Mexican army on March 2, the Declaration of Independence was signed at Washington-on-the-Brazos. On March 6, Travis and Bowie died after a thirteen-day siege at the Alamo. During it, Travis answered Santa Anna's final call to surrender with fire. He, Bowie and their army of about 150 men would rather die than let Mexico advance. As the battle ensued, the lawyer wrote a patriotic letter "To the People of Texas & All Americans in the World." Its heartfelt cry for reinforcements describes the

unsurmountable odds against the powerful Mexican army. His impassioned pledge to defend the fort ended with a flourish: "Victory or Death."

Texas settlers were horrified at the news of the defeated campaign. Grant and Johnson were also killed in the battles leading to the Alamo. The Dorsett family were heartbroken at Travis's death. Their fear and sadness was not over. At Goliad, where Fannin was in command, Mexico gathered the Texans it had captured. On Palm Sunday, twenty days after the Alamo fell, Mexico marched between 425 and 445 Texans out of the fort. The men were lined between two rows of soldiers and massacred. They were shot at point-blank range. Those who survived were clubbed and knifed to death. Those who were lame from battle and couldn't perform the death march were killed inside the fort afterward.

After all the men were dead, Fannin, who had watched the massacre, was led into the courtyard. He was tied to a chair and blindfolded. He asked for his family to receive his belongings and that he be shot in the heart. He asked for a Christian burial. None of it happened. His body was burned with the bodies of the other Texans killed that day.

The news shocked Texas communities. In the following weeks, settlers were fleeing the approaching Mexican army. On March 20, Morgan was named the commander of Galveston Island, where many of the settlers were being sent. Having decided not to enter slave smuggling like Monroe, Morgan and John Austin had spent the previous year creating a land company, the New Washington Association, with prosperous New York investors. In the Northeast, John had two schooners built and registered. The *Flash* was a war schooner. The *Kos* was named after Morgan's son Kosciusko. These schooners, along with the *Cayuga* and every other Texas vessel, swept the rivers in anticipation of the Mexican army's arrival. In Nacogdoches, Texans intercepted orders that the Mexican army would shoot anyone who had a gun and force everyone else to flee.

Moving hundreds of Monroe's slaves was a logistical nightmare. Monroe loaded between 50 and 80 of his slaves, many of them children, onto the *Flash*. As a result, some of the New Washington residents were left behind because the slaves took up so much room. The schooner took Monroe's slaves to Galveston. In a different case, it took at least 120 slaves to Nacogdoches, where they were under Ritson's care.

The *Flash*, under Captain Luke Falvel, was an impressive schooner to Texas settlers, but it was one of the smallest vessels to enter New Orleans. It didn't carry as many passengers as some expected. During most of April, after moving the settlers, it delivered troop reinforcements, supplies and other necessities for the battle, including the cannons.

Texans prevailed at the Battle of San Jacinto and captured Santa Anna. They held him prisoner for weeks until he agreed to lobby for Texas to become a sovereign nation. On the way to Galveston to tell the settlers the news, Captain Robert J. Calder saw soldiers stopped at Edwards Point after they left the battlefield. He said, "The party reached the Edwards place at 'Red Fish Bar' about noon of the third day. Here they found some provisions and a box of fine Havana cigars."

It also seemed that Monroe forgot one of his slaves. Calder said, "The only living thing they saw was a wild African negro, probably one introduced by Monroe Edwards."

The sheer number of slaves and smuggling deals Monroe had to keep up wasn't making the high life easy for him. He had cash-flow problems. He started rolling debt and looking for collateral for the loan with George Knight & Co. Two days before the Battle of San Jacinto, he was in New Orleans making a deal with his partner. In return for covering the Knight & Co. loan, Monroe would make Dart an equal partner. He offered Dart half ownership in his Texas property and slaves. Dart agreed, and the following month, Monroe followed through and gave Dart power of attorney. Monroe also told Knight & Co that he was going to obtain a loan from McKinney and Williams in Galveston. That loan was going to cover $500 per slave. Then he was going to make another quick slave run to Cuba to pay all his debts.

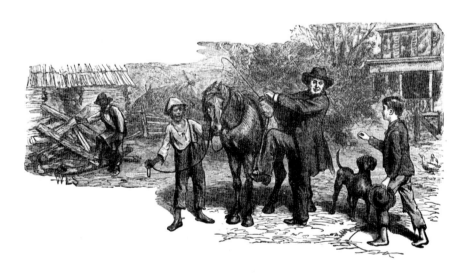

Monroe is helped into a house by slaves at Chenango while a local boy greets him.

In June, Monroe had at least two hundred slaves scattered between the Sabine River and Nacogdoches as a result of the battle. He decided to take the half he had moved along the coast to New Orleans for sale. He used the *Kos* to gather them. He made a deal with Captain James Spilman to pick up fifty-four slaves from Bolivar near Galveston, and the *Kos* stayed at Bolivar for two days. There, Ashmore boarded the schooner for New Orleans. At the mouth of the Sabine River, the *Kos* picked up Monroe and forty slaves. They all sailed to New Orleans. The total charge was $440.

In August, Dart had signed a note for $35,410 with George Knight & Co. to cover Monroe's debt and became the collateral Monroe was looking for. In September, most likely using funds from the New Orleans sale as down payment, Monroe bought two plantations. His first was the Chenango Plantation in Brazoria. He bought it for $35,000 from fellow slaver Benjamin F. Smith. The plantation slaves, cotton and corn came with the deal. The other was on the San Bernard River and had a quarter league. He paid Edwin Waller $5,000 for it. He also bought 622 acres elsewhere on the San Bernard River for $20,000.

Monroe was moving from slaver to real estate developer as quickly as he could.

13
THE BRITISH ACCESSION

Without question, Monroe's big Texas fortune was built on illicit human trafficking. He was worth almost $140,000 after Bowie and Fannin died in the revolution. By comparison, between 1818 and 1820, Bowie and Lafitte profited a total of $65,000 from their Galveston marketplace.

Monroe had over 4,000 acres from his inheritance after Moses died. He had two leagues, representing over 5,000 acres, on the San Bernard River. He had 80 acres on Cedar Lake, and the Chenango Plantation sat on 1,600 acres. He still had control of ninety-two slaves, two hundred cattle, eight oxen, two horses and one mule.

In 1837, he had dreams of building towns. In addition to owning a share in a future river town called San Bernardo, he attempted to transform his father's property into a town. He and William "W.B.P." Gaines platted a site that they named San Leon and enticed investors to develop it.

With Dart as co-signer on the George Knight & Co. slave debt, Monroe used slave profits to move into the Texas real estate bubble. He was leveraging debt, rolling it and flipping real estate. He bought more tracts from Peyton Splane, a leader in a volunteer Texan army. Those were outside Brazoria. He didn't keep Chenango for more than two days. He flipped it to D.C. Hall for a $500 profit. Monroe could have probably made more money because Hall sold it one month later for $40,000, $10,000 more than Monroe paid for it.

Monroe also had fallout from his slave runs. Between 1837 and 1840, he filed eighteen lawsuits for nonpayment against Brazoria farmers. He sold each slave for $400. If asked, he would agree to "tote the note" for $16 per

The fertile land of Chenango in Brazoria.

month until the debt was paid. He prevailed in most of the cases, although it was unclear if he received the payments. The dubious nature of slave trading led to complex and untrustworthy deals. In one case, it was entirely possible that Monroe was able to secure a league, among other collateral, for a house servant he sold for $800 in one case. He was awarded $20,399 and twenty slaves.

The year 1837 was also one that was going to fulfill a lifelong dream. Monroe was going to Europe. His high-dollar lifestyle had left him enamored with royalty and their social lives. He wanted to visit England in style. To

Dart and Monroe fish in a river near Chenango.

fund the trip, he sold land along the San Bernard River. That piece, which he sold to Gaines, made him $40,000 in one year. He also sold a small piece of his share in San Bernardo for $5,000. Ashmore agreed to carry on his affairs for him while he globe trotted.

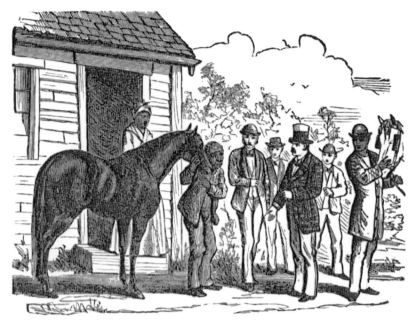

EDWARDS LEAVING HIS HOME FOR ENGLAND.

Monroe leaves for his first trip to England.

If Monroe was going to be entertained by the aristocracy, he would need letters of introduction. To gain them, he went to the United States government. He headed to Washington, D.C., where he met William Wharton.

Wharton was a delegate in the Convention of 1832, during which he wrote the petition for Texas statehood. He was also president of the Convention of 1833 and a delegate to the temporary government Texas created to manage the revolution. He and Austin were designated commissioners to the United States government to seek aid for the Republic of Texas. Wharton agreed to speak on behalf of Monroe and gave him letters of introduction from all the right people in Washington.

On his way to Europe, Monroe traveled to New York, where he arrived in May 1838. He roomed in the luxurious Astor House in New York. The Astor was the preeminent residence on Broadway in New York's Lower Manhattan. John Jacob Astor began building it around his own home in 1834. It made a splash when it opened in June 1836 and became a symbol of New York's burgeoning presence on the worldwide financial stage. The magnificent five-story hotel featured 309 rooms with gaslights that were

fueled by the hotel's own gas plant. Bathing rooms and toilets were on each floor. Steam engines pumped water through the building. Servants' rooms were on the sixth floor. When Monroe was there, it was the marvel of the United States as its only luxury hotel.

In New York, Monroe's unattended business in Texas came to haunt him. He ran into John Austin, who demanded to know why he hadn't been paid for the trips Monroe had booked on the *Kos*. Monroe claimed that the payment was a mistake. He said he never agreed to it, carried on with his journey and left J.P. fuming. Monroe wrote an insulting letter to Morgan about the matter.

Within weeks, Monroe made it to Britain, and the letters that Wharton had secured worked. Monroe was received with open arms in just days. He decided to call himself "Colonel" and pretended to be a hero from the Battle of San Jacinto. He was a stark contrast to what European royalty expected a Texan to be. They thought "semi-barbarians" had beaten Mexico. Instead, Monroe was "a very elegant gentleman" and carried a natural ease in the courts. His good looks and manners made him all the rage among the British aristocracy. The Duke of Devonshire and others entertained and fêted him with tours, galas, dinners and parties. At all of them, he was asked to recount the Texas war for independence. He added lies about his own heroic part in the battle with such modesty that people believed they had to be true. He also hosted dinners and parties in return.

His grand entrance into high society also included an affair with a lady he met at the opera. A few days after they exchanged glances at the theater, he saw her in a carriage. They had an awkward exchange, but he still received a note at his hotel to meet her at Leicester Square. Her name was never recorded, but she was married to a husband who neglected her. Monroe met the lady of the opera at her mansion and at the square every day. Affairs were condoned in England's high society at the time, as long as they were discreet. At the Duke of Devonshire's home, it would have been common for a man like Monroe to maneuver a room near the lady's during one of the weekend parties. As long as they didn't display their dalliance in public, his request would have been granted.

His quick accession was so firm that he was able to secure an invitation to Queen Victoria's ascension. Her coronation enthralled the nation. She was young and vibrant. No expense was spared. Parties that led up to her ascension were attended by the Duke of Wellington, whom Monroe met, and other British dignitaries and members of the aristocracy. The coronation line

EDWARDS IN ENGLAND.

Monroe enjoys the good life in England.

formed at Buckingham Palace, and trumpeters from the Household Brigade led the procession to Westminster Abbey.

Foreign ambassadors, ministers, bands and cavalry followed. In carriages were the Duchesses of Kent and Gloucester, the Duke and Duchesses of Cambridge and the Duke of Sussex. Queen Victoria arrived in a carriage drawn by eight cream-colored horses. They processed along Constitution Hill and Piccadilly and wound their way to the west door of the abbey. The Duke of Devonshire carried the Curtana. The aristocracy was in full regalia. One attendee wrote, "The sight in the Abbey was brilliant in the extreme. Galleries had been erected in the aisles. And above 10,000 of the greatest and most famous people in the land were present."

Monroe was one of them.

Right: Monroe meets the Duke of Wellington and other nobles in England.

Below: Monroe is presented to Queen Victoria.

BRITAIN WAS ABOUT TO change Monroe's life in more ways than he imagined.

While he was living the lie of a great Texas hero with the royals, George Knight & Co. called in Monroe's slave debt. With Monroe out of town, Dart got the announcement that he needed to pay. He was furious. He sued Monroe and headed toward Texas. When Ashmore got the news, he summoned Monroe to return.

Ashmore was certain that Dart, who had once owed a Natchez bank $300,000, was trying to swindle his brother. Dart claimed Monroe had taken the profits from their slave runs and the property at Chenango for his own. Not only had Dart covered the Knight loan, but he now claimed he was the victim of theft. In response, he made a claim on Monroe's estate. The debt call was the result of Britain's involvement in Texas and the United States. British banks caused the Panic of 1837 and a global recession.

Cotton and slave prices rose sharply between 1834 and 1837, when Texas became known as the new frontier of the southern plantation economy. Britain's financial interests in the United States were vast and both legal and illegal.

In 1835, legitimate British interests included the nation's transportation systems and its western expansion. Within a few years, British reserves began to dwindle from their zealous lending in America and Texas. When the country began raising interest rates to shore up reserves, this created what is known as a "burst bubble." It lasted almost ten years.

As soon as the rising British interest rates hit New York, banks ground to a halt. They stopped lending, and that caused a horrendous effect on cotton prices. Bond-backed securities funded the cotton economy, and when it crashed by 25 percent, the entire commodity system failed. The whole episode took only eight weeks.

But that wasn't the only bad effect the interest rate spike had. Simultaneous to the British investment bubble, America had a western-front real estate bubble. President Andrew Jackson's administration thought that the best way to control over-inflation was to make a national central bank. The Second Bank of America allowed investors to buy western land with gold and silver. As a result, the nation's federal reserve funds were running low, just like Britain's. The Second Bank of America had scant reserves because it was lending all its gold and silver to western land developers. When New York halted lending, the American real estate market also collapsed.

Martin Van Buren, who was on Jackson's cabinet, was elected president five weeks before the crash happened. He believed in the current fiscal policies, so he didn't intervene. Since the government did not rush to stabilize the system, the entire New York banking system collapsed.

Monroe receives a fond farewell from the lady of the opera.

In Monroe's case, George Knight & Co. had not yet collapsed, but it was calling in its debts to shore up the Baring Brothers' reserves. Monroe's call from Ashmore put an abrupt end to his glamorous lifestyle in England. The aristocracy was crushed but understood that business called. The lady of the opera gave him one of the longest farewells in Leicester Square, where their romance began. She gifted him with a large and expensive diamond, which he promptly accepted.

On the final leg of his journey, Monroe returned via the steamship *Cuba* with a slave named Rickard. The vessel was a regular packet that transported passengers between Galveston and New Orleans. Bogert and Hawthorne built the luxury passenger ship for $100,000 in 1837 and spent another $25,000 on it in 1838 while it was in New York. It's unclear where Monroe found Rickard, but according to Van Buren, Monroe brought him ashore when they arrived in New Orleans on February 6. Monroe was arrested and imprisoned for violating the slavery law of 1818. Someone must have intervened on his behalf and contacted the president. Upon review, Van Buren stated that he believed Monroe when he said he had made an honest

ARREST OF EDWARDS IN TEXAS.

Monroe is arrested in Brazoria.

mistake: "And whereas it has been satisfactorily shown that the violation of the law aforesaid was committed in ignorance and without any willful or fraudulent intent, on the part of this said Edwards…"

Edwards was required to pay court costs and other administrative fees related to his imprisonment in exchange for a full pardon on February 21. With that, Monroe headed on to Brazoria, and on the first Monday of March, he stood trial for stealing from Dart.

14

CHENANGO

Monroe's first swindle was against his own friend Holcroft during their first attempt to run slaves out of Africa. Whether it was to buy nicer clothes or for another reason, Monroe created a fake script and had Holcroft cash it. Holcroft had no idea he was being used when he entered a New Orleans bank.

Years later, a chance meeting with a stranger would help Monroe hone his advanced forging skills. When he took his mother and sister to Mississippi, he paid a man to teach him how to wash letters and forge them. Monroe learned the skill in one sitting. In the 1800s, letter washing got a new and sophisticated criminal facelift. Over the next century, acetone and other chemicals would be discovered that could wash ink, but in 1834, benzene and bleach were the only methods. Bleach was discovered in the 1700s. In 1834, scientists noticed that when benzoic acid was heated with lime, it produced benzene.

Monroe learned how to create the chemical, douse the top part of a letter in it, save the signature and then dry the paper. The result was an empty sheet with the legitimate signature of the original writer. From there, he was taught to write whatever he wanted on the dry paper and pass the letter off as the original writer's. Since people knew one another by their signatures and seals, a forger could write what he wished, and the reader would believe it was written by the writer. Only a trained eye would be able to tell if a paper had been washed, and only a chemist would know how to bring the washed writing to the surface. For the most part, the crime was undetectable. By 1838, Monroe had perfected the technique.

Above: Chenango Plantation. *Courtesy of the Brazoria County Historical Museum.*

Left: Monroe experiments with acids to extract ink.

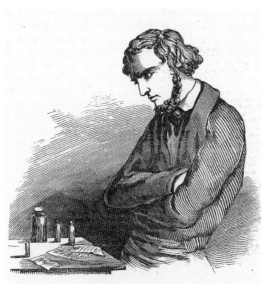

EDWARDS EXPERIMENTING WITH ACIDS ON THE EXTRACTION OF INKS.

When he arrived in Brazoria, he hired the most prominent attorneys he could find. John Waltrous was the first attorney general of Texas. John W. Harris was new to Brazoria but had a law partnership with Elisha Pease and Monroe supporter William Wharton. Harris had one of

EDWARDS AND KITTY CLOVER.

the best reputations in town. After Monroe hired them, he didn't worry about the trial anymore.

Dart hired the Jack and Townes firm. The lawyers were William Jack, Robert J. Townes and Patrick C. Jack. Dart was low on cash, so the lawyers agreed to 5 percent of the total judgment. They accepted ten slaves as collateral. Among them was a fifteen-year-old girl named Kitty Clover, with whom Monroe had begun a romantic relationship. Kitty soothed the broken heart he nursed for the lady of the opera. Incidentally, Monroe did not own her; another planter did.

It's unknown how Monroe reacted when he learned his friend Patrick Jack was involved, but it couldn't have been well. It's also not known why his friend would agree to prosecute him. Nonetheless, the public stood with

Monroe. He was popular and beloved enough that no one questioned his integrity. Rumors spread around town that Dart had questionable business practices and couldn't be trusted.

When the trial began, the entire Brazoria community flooded the courtroom to watch. Monroe's attorney promptly provided two bills of sale that showed Dart had conveyed his portions of the Chenango Plantation, the other lands and the slaves to the Brazoria gentleman. Captain Peyton Splane, Ashmore Edwards and John F. Pettus were signed as witnesses to both. When Monroe's attorney demanded to know if Dart had signed the documents, Dart's hand shook as he held them and realized it was his signature. He was in disbelief. Monroe's counsel immediately called for the case to be dismissed.

Dart cried, "No, I don't mean that I signed it. I never signed any instrument such as this. It is a forgery!"

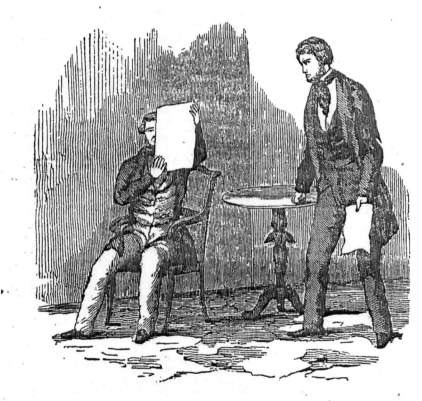

EDWARDS SHOWING THE FORGED INSTRUMENTS TO HIS BROTHER.

The trial continued to hushed whispers and stirs in the room. Ashmore took the stand after Judge Benjamin C. Franklin quieted the room. Monroe's brother stated with all sincere belief that he had witnessed Dart sign the documents.

Dart sat with his attorneys and studied the bills until he finally realized they were written on a specific type of paper. He used that sort of paper only for letter writing. His attorneys jumped to their feet and asked for a recess. They didn't tell Monroe or his attorneys, but they were getting two local chemists to determine whether Dart's letters had been washed. When Monroe learned what was going on, his attorneys noticed he became ruffled, but they didn't understand why.

Dr. Charles B. Stewart and Edmund Andrews both testified that the papers looked like they had been washed. When Andrews tested them, he was able to reveal faint, spidery lines that proved writing had been erased under the bills of sale.

Monroe was made, and his elaborate scheme was revealed. His slip in the crime against Dart was not the forgery technique but in the execution of the swindle. To convince the three men that they were witnessing Dart execute the bills of sale, Monroe hired a low-level gambler he knew in Baton Rouge. The gambler bore a striking resemblance to Dart. Monroe had him come to the Tremont Hotel in Galveston, where he organized a meeting for everyone. Dart was staying in the hotel, so nothing looked unusual when the gambler appeared. His appearance was so similar to Dart's that no one questioned him. All three men believed they had been watching Dart convey his shares to Monroe.

Monroe's attorneys, who were unaware of the swindle, made a fast plea that he should not be held accountable for anything Dart did to the paper before the conveyances. If Dart washed the paper, that wasn't Monroe's fault, they argued.

The court did not buy that argument and levied a judgment of $99,088. Dart was given the property, including Chenango, until Monroe paid him. The next day, Sheriff J.B. Calder arrested Ashmore and Monroe for forgery. Monroe's bond was denied, and he was placed in jail.

At this time, the slave girl Kitty Clover ran to rescue her love. Kitty was the illegitimate daughter of a Spanish grandee in Cuba and a slave woman. She had full lips, a curvy figure and golden-brown skin. She borrowed the clothes of a boy slave at Chenango and walked to the jail, where she pretended to be a boy named Henry Clover. She asked to see her master, Monroe Edwards. The guards let her in. They told Monroe that "Henry" could stay since the boy was his personal servant.

Pelicans fly over Galveston Island near the Tremont Hotel.

In a few days, the attorneys arrived to take Monroe to San Antonio, where a judge agreed to determine if he could make bail. Kitty dressed as "Henry" went with them, and along the way, Monroe told the attorneys that the boy needed to get a message to Ashmore, so he was sending the child to Brazoria. In reality, Monroe sent Kitty to spy on Dart and the Jacks to find out what they had planned for him.

With that, the men went to the hearing, where Monroe's bail was set at $5,000, and the secretary of the Texas navy, Colonel Louis P. Cook, acted as his security. As they headed back, Kitty appeared at a hotel where the men had stopped. She waited for them to tie their horses in the stable and passed Monroe a note that explained what she had learned.

Dart had two more forgery warrants to arrest Monroe for if he came back with bail. Captain Splane would testify and so would a Tremont hotel clerk. The clerk pieced together something that had puzzled him for a long time. He would testify that he saw Dart in his room shirtless at one moment and then, seconds later, saw him in the lobby completely dressed in a meeting. Given the events of the trial, the clerk was now certain he'd seen an impostor.

In Texas of 1839, a forgery conviction meant Monroe would hang.

CHENANGO PLANTATION WAS NAMED after a town in the state of New York.

When Dart took control of the property, he converted it from cotton production to sugar cane. It wasn't used for slave smuggling anymore. Monroe never returned, but he was never rid of Chenango. The Dart trial wasn't the only problem Monroe had with the plantation. Even though he sold it after two days, Monroe still owed Smith $18,000. In fact, Smith had filed a Chenango lawsuit against Monroe months before Dart did. Monroe never paid the judgment. Other cases were also fast coming after the Dart trial. Between 1837 and 1846, Monroe was named in twenty lawsuits. Most of the cases were fallout from his slave runs. In 1838, he was convicted of selling a critically ill slave, which cost him $1,200. He was also convicted of injury to a slave and paid $363 in medical fees. It was also widely thought that he mistreated his slaves when two of them broke into a house and stole food. These were smaller suits, and none of them sullied his popularity or community respectability.

Morgan referenced the "perils" Monroe was having in Brazoria when he answered Monroe's letter in 1838. He dismissed them as minor incidents that could be forgotten even after Monroe hurled insults and angry torts at him. Morgan defended himself in a five-page handwritten letter. Morgan told Monroe to prove him wrong as he detailed the ways Monroe had ignored John Austin and the New Washington Association. Monroe's refusal to pay for the slave transport had gotten so bad that Morgan couldn't manage it anymore. The New York investors were now involved.

At first, Morgan scolded him for not paying his bills or seeking help. He hurled insults back at Monroe, calling him a "store boy." Then the letter changed tone, and he expressed sadness that Monroe seemed to be abandoning him. He noticed that when Monroe had been near Morgan's Point in the past, he didn't stop by. He also expressed disappointment that when Monroe was in New York, he wasn't gracious to the investors Morgan was working with. He was left believing that Monroe was cutting ties, and it upset him. Toward the end of the letter, Morgan pledged his friendship and ended with: "I am not your enemy."

Texas's love for Monroe plummeted quickly when his forgery and bail jumping came to light. In March 1840, Sheriff Calder sold one slave to pay a debt to Sarah Kennedy. In April, the courts awarded Dart an additional $18,376 for interest he'd earned on his original judgment against Monroe. Monroe was also ordered to pay $357 in court costs. Also that month, C.R. Patton and Edwin Waller were in court on a debt dispute involving Monroe.

Morgan was right that the New York investors were not as enamored with Monroe as the rest of Texas was. After the Dart trial, one colleague wrote to Morgan to tell him that word was getting around New York that Monroe should be avoided, no one should write to him and at least one important businessman didn't like him.

Dart continued to fight Monroe until the day he died. He took advertisements out, warning people to not go into business with the scoundrel. After all his effort, he died before the transactions on his final judgment were finished. His wife took over in his stead.

In October 1840, the global recession reached George Knight & Co., and the bank began liquidating. In the course of that, the bank filed for the repayment of Monroe's loan for eighty slaves.

Dart wasn't without blemish, although he eventually rose to prominence. He helped the community start the first Masonic lodge in Texas, which was dangerous because Mexico considered the Masons to be extremists and subversive. It took years and a revolution before it could be established. Once it was, Dart held several high offices.

At least one community member had no problems challenging Dart's attack on Monroe. In June 1840, Monroe's land developer partner, W.B.P. Gaines, wrote a lengthy newspaper letter that defended his bail-jumping friend. He reminded people about Dart's bank problems in Natchez and recounted his own business dealings with Monroe. Gaines didn't like Dart and said that he had suffered at the hands of his family. He said he wrote the public letter so there would be some fair statements about Monroe in the community.

One year later, with Monroe not present, Gaines filed suit and was awarded more than $50,000 in debt repayment. No Texan ever wrote a positive public statement about Monroe again.

15

"NAPOLEON"

At midnight, just hours after he learned of Dart's warrants, Monroe left Texas with Kitty. They hid near the San Bernard River until they could reach Chenango for supplies and gold. Then they escaped to New Orleans and on to Natchez, where Monroe told his mother he had been betrayed by friends and persecuted. She believed him.

He had not been given the life he wanted and the one his family wanted. Starting with his grandfather to his uncles, his father and himself, fortune arrived but always left each of them squandering. They accomplished big feats and made good names for themselves, only to let temper or business acumen diminish them. They used powerful friends, and those same friends exploited them. They were heroic but never honored. They were first and foremost economic opportunists, and they paid high prices for the glory that offered.

By June 1840, the pair had reached Ohio, where Kitty continued to pretend to be a boy slave named Henry. Monroe found a wealthy planter he used to know and was introduced to the world of abolitionists. He absorbed their arguments and stories. After a few weeks, he announced that he'd had a change of heart and wanted to free all his slaves, including his slave boy Henry. He took out a newspaper advertisement to announce his decision.

He concocted a story that Dart had forced the Cuban slaves on to him and that he was going to Britain to find a way to send them back to an abolitionist colony in Africa like Cape Palmas. With the law and a hanging death awaiting him in Texas, Monroe had become a well-dressed gentleman

EDWARDS AND KITTY CLOVER DINING IN THE CHAPPARAL.

Monroe and Kitty eat in the wilderness while they escape Brazoria.

without a community. He wrote to Texas president Mirabeau Lamar and told him about his new support for the abolitionist movement.

The move was shrewd. Britain was using the abolitionist movement as a pawn in its negotiations with Texas and the United States. To entice the United States and Texas in the years after the panic, Britain was offering large loans in exchange for abolishing slavery. Sam Houston and Mirabeau Lamar were hoping to make a deal and sent James Hamilton as an envoy. The hope was that, with enough funds, Texas could fund itself as a sovereign nation. Narratives of Texas slave smugglers or apprenticed Cuban slaves

being forced onto plantations were not good for Texas or the United States. This "repentant slaver" narrative that Monroe used was problematic for Texas and, if used correctly, could become his new speculation.

He traveled on to New York to meet with the most influential U.S. abolitionist, Lewis Tappan. Tappan, if convinced, would be an incredible ally. When slaves from Lomboko rebelled and overtook the *Amistad*, Tappan had raised funds to pay the legal fees so the slaves could gain their freedom. Monroe asked him to fund his trip to England in hopes of building connections to give his slaves their freedom. The manumission of his slaves was going to cost between $70,000 and $100,000, and he didn't have that kind of money. He asked Tappan for $5,000 to fund his trip. Tappan responded favorably to the idea and began a relationship with Monroe. Monroe was given a place in Tappan's church, and "Henry"

EDWARDS AND WINFREE AT THE BARON SEAGRAVE'S.

was put in Sunday school. The two met at least a dozen times to discuss Monroe's trip to Britain.

Over the course of the weeks they were together, Tappan began to distrust the so-called repentant slaver. He checked out Monroe's story and found that while newspapers proclaimed Monroe had manumitted slaves, he had never followed through with legal paperwork. When Monroe learned that Tappan might back out, he was furious. He sent him a letter that offered to secure the trip via bonds. For every slave who wasn't freed, Monroe would pay Tappan $1,000. For every one that was, Tappan would pay him $1,000. In risky business, unsecured bonds are a common ploy. Tappan backed out.

Monroe still went to Britain in 1840 through another ruse. To help him, he brought along a gambler he knew, Colonel J.S. Winfree. Monroe had earlier received autographs from U.S. senator Daniel Webster of Massachusetts and U.S. secretary of state John Forsyth. Using them, he created forged letters of introduction. He presented one to Earl Spencer III of Althorp, who gave Monroe money for lodging. Lord Spencer was a staunch abolitionist in England and influential in progressive politics there. The wealthy royal fancied himself a farmer and had cows roaming his property, which was the size of today's Manhattan. He had one farm boy whose entire job was to lead the cows away from the manor's windows when they got too close. The Spencers of Althorp also had a long history with America. They were related to George Washington and helped his family when they fell on hard times in England. For many reasons, Spencer was an easy target.

Monroe also met with Lord Brougham, a Scot who became the lord chancellor of Great Britain, and got nowhere when Hamilton intervened. Spencer wrote to Webster to reveal how he'd been swindled by Monroe, and Webster promptly published his letter.

While Monroe was trying to find someone to swindle with his story, Kitty become pregnant. He made provisions for her in Philadelphia. She sailed with Winfree on the *Ontario*. She was supposed to have enough funds to live comfortably until he returned, but the money ran out. She gave birth to a boy in a charity hospital in New York, where she stayed.

Monroe headed to France and there concocted what would become his final scheme. He saw Holcroft there, and his old friend supported his idea as a way to raise money for a new Texas colony. They would develop the land together. While Monroe was in Paris, a bank heist and forgery stunned the world. The job was conceived by a forger with the help of a burglar who broke into a New Orleans bank and stole certificates of deposit, which they cashed throughout the nation. The idea that they

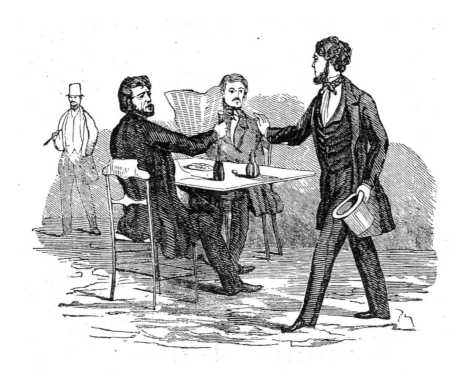

Monroe meets Holcroft for the last time in Paris.

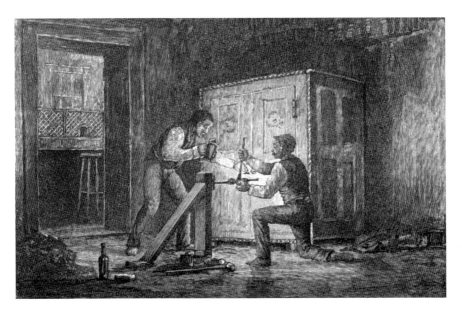

Monroe knew the account of the robber and forger who created the largest bank heist of his time.

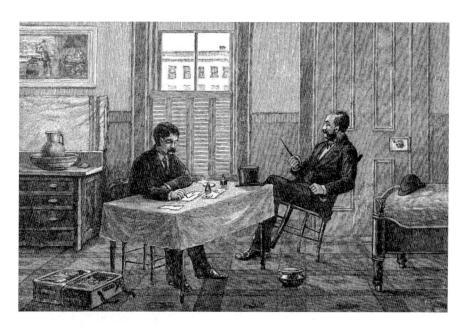

Monroe considers a forgery grander than the one he learned about in the newspapers.

could make their plot work at multiple banks for more than $50,000 astounded Monroe. He was determined to outsmart them and execute a bigger heist. Once he had concocted a scheme, he headed to Philadelphia to find Kitty and start the plan.

He pretended to be two different people, J.P. Caldwell and H.S. Hill. He first wrote a letter as H.S. Hill to Munsell White & Co. He told them he wanted to talk to them about "his plantation" and wanted to know the name of their New York contact since that was where he was. He sat back for several weeks, knowing the New Orleans bank would take a while to respond. During that time, he began a courtship with Caroline Phillips as a cover in case he was pinned as his upcoming alias, J.P. Caldwell. Monroe stayed as a boarder as her parents' home, and he made sure Caroline was with him whenever "Caldwell" did anything.

He also enlisted the help of old friends, like a man known only as "Child," who helped him complete certain parts of the swindle and forgeries.

The bank wrote back and told him to use Alexander Brown & Bros. in New York. Tellers there would be able to conduct business for him on its behalf. Then, using his alias H.S. Hill, he wrote to Brown & Bros. and asked it to advance $50,000 to J.P. Caldwell for use for his cotton. Caldwell, he wrote, was in Virginia buying slaves. Later, Edwards

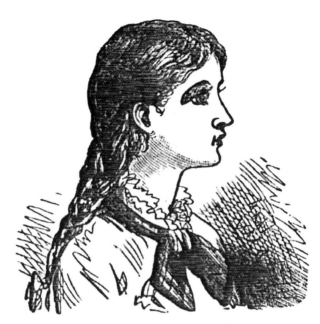

Caroline Phillips, Monroe's fiancée and alibi for his New York forgeries.

MISS PHILLIPS, EDWARDS' FIANCEE.

Monroe courting Caroline.

MONROE EDWARDS AND MISS PHILLIPS.

EDWARDS AND CHILD PREPARING THE SPURIOUS
JOHNSON BOND.

EDWARDS INTRODUCING THE PERJURY TO CHILD.

Above: Monroe and Child concoct the New York forgeries.

Left: Child contemplates Monroe's scheme.

Monroe cashes a check in his elaborate bank swindle.

created forged financial documents from his exchange with the banks and appeared at the New York bank as Caldwell. The most prestigious bank in America gave him the funds.

He intended to do this same scheme at other banks and sent out several letters to about seventeen of them. He obtained funds from Johnson & Lee in Baltimore using the ruse. The scheme ended when the New Orleans bank told Brown & Bros. that it didn't know Caldwell. The manhunt was on. Prosecutors at his trial said, "These transactions astounded the commercial world. The ability with which these frauds had been conceived and executed, threw distrust all over commercial transactions."

To confuse investigators, Monroe sent an anonymous letter to Brown & Bros. claiming that Alexander Powell, a friend who looked similar to Monroe, was leaving town. The letter said Powell was the man investigators were looking for. When Powell was arrested as he boarded a steamer in Boston, he was indignant when he realized Monroe had betrayed him.

He could scarcely believe his eyes. His lips turned white with rage, and suddenly fronting the officers, he exclaimed in a shrill voice of passion, "Do you wish to know who the great forger is?"

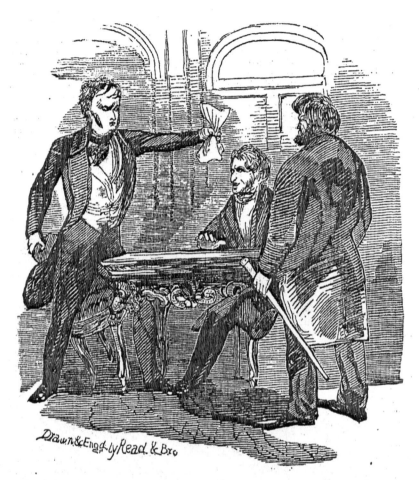

ARREST OF POWELL AS THE SUPPOSED GREAT FORGER.

Alexander Powell is mistakenly arrested as Monroe.

"We do!"

"It is Monroe Edwards!"

Within a few days, Richard Vaux, a Philadelphia detective, realized that Monroe was still in town. He went to the house with a judge and several police. He knocked on the door, and a servant girl answered. Monroe was eating, and the girl went to get him. Within a moment, he appeared. He was wearing fine jewelry and was dressed with "scrupulous exactness and paid attention to every detail of his appearance."

Vaux walked to him and said, "Good evening, Colonel Monroe Edwards. I believe you are Colonel Monroe Edwards if I recollect aright?"

Monroe replied, "I am that person and am very glad to see you."

Vaux made a signal, and his team entered the room. Monroe was handcuffed. He said nothing. As Vaux was leaving, he remembered "a very agile, slim, light-colored mixed race teenage boy" rushed at him with a long knife and lunged at him with it. Without thinking, Vaux knocked the boy to the ground and took the knife from him. The boy ran. When several of the boarders at the inn appeared, they told him it was Kitty. She was dressed as a boy.

Vaux confiscated Monroe's trunk, which had thousands of dollars and banknotes. Monroe was extradited to New York City. He immediately hired some of the most high-powered attorneys in the country to defend him. Tom Marshall, who was a congressman, took leave from his duty to defend Monroe. *New York Courier and Enquirer* reporter Colonel J.S. Watson

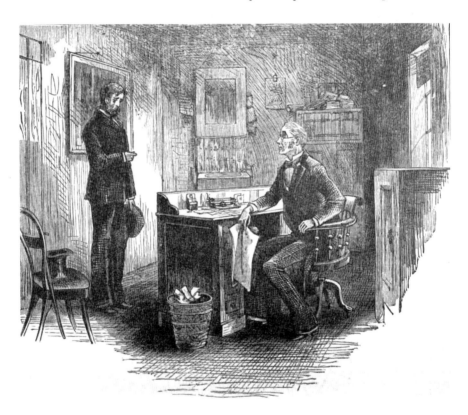

Monroe discusses the trial with his lawyer Robert Emmett.

Webb criticized him for it. Marshall was so angered at the insinuation that Monroe wasn't worth the effort that he challenged the reporter to a duel on the "field of honor." Marshall shot Webb in the leg and left him lame for life.

Another defense attorney was a Kentuckian, John Crittenden. Crittenden had just finished a tenure as the U.S. attorney general. He was now back in Kentucky serving in the Senate. An acclaimed lawyer, he was penniless in 1842 during the trial. His friends had to find him a home. His financial situation may have been part of the reason he left his political seat and defended Monroe.

One account claims Monroe also swindled another defense attorney he wanted to hire. He forged a letter to Robert Emmett. It was a ploy to convince Emmett that Monroe had a vast Texas plantation and funds to pay him. The letter said a New Orleans bank had just deposited more than $1,000 in Monroe's account. Emmett did not notice the local stamp.

By the time the trial began, the New York bluebloods were enthralled. The audience included Alexander Brown, whom Monroe had swindled. Alexander Brown & Bros. was the first investment bank in the United States when the elder Brown opened its doors in 1800. Within a few years, it had organized the country's first public trading. The Browns had expanded into cotton and tobacco in 1834. They considered their bank to be the best in the America and promoted it as such. Monroe's swindle had made him the talk of the town.

As was his custom, Monroe was impeccably dressed each day. Women stuffed the courtroom to fawn over him, according to the *New York Daily Tribune*:

> *At twenty minutes past ten o'clock the hero of the scene, Colonel Monroe Edwards entered, as blooming and fresh in appearance as if just turned out of a band box. He was dressed in precisely the same manner as yesterday and seemed just as unconcerned, exhibiting the greatest nonchalance imaginable.*

While Caroline was able to account for Monroe's alibi, there were holes. At one point, he wanted Ashmore to find Holcroft to testify on his behalf. Ashmore never found Holcroft, and Monroe never saw his old friend again. To help his brother, Ashmore pretended to be Holcroft and took the stand, according to one account. That effort fell flat when someone recognized Ashmore. Monroe suspected the slaver was dead.

PROBABLE FATE OF THE SLAVER HOLCROFT.

Monroe eventually believed Holcroft perished at sea.

Much of the most damaging testimony came from Vaux. At the end of the trial, Monroe received ten years' imprisonment. He had one conversation with the detective after the decision was handed down. He spoke with a "studied politeness."

"I am very glad to have this opportunity of speaking to you," he said. "I want to say one thing to you that is important for you to remember. I am going to kill you the moment I come out of Sing Sing. I give you this notice as from one gentleman to another."

Vaux responded with the same politeness: "I am very thankful to you Colonel Edwards for giving me this timely notice. It is very gentlemanly of you to do so. I will give you the opportunity at any time you desire. I have only done my duty and am prepared to take the consequences. I only ask that when you make that attempt, you will look me in the face."

Detective Vaux testifies at Monroe's trial.

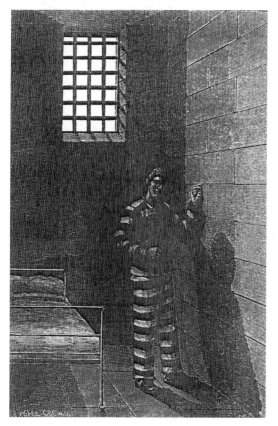

Monroe in his cell at Sing Sing.

He stared at Monroe until the convict went pale and began to tremble. His gaze didn't end until the guards pulled Monroe away.

Monroe was remembered as the "Napoleon of forgers" for years after the trial. During his time in Sing Sing, he tried to escape several times. His last attempt almost worked. He tried to convince the guards that he had drowned. Instead, he climbed into a coffin with some food and a bottle of brandy. The plan was that he'd be carted off the island.

In 1842, Sing Sing was in the throes of the cruel Auburn System, making the prison legendary for its extreme punishment. Inmates were not allowed to speak and worked for long hours. When the guards realized Monroe had not committed suicide, they began a search. Once they found him, he was beaten severely. Six lashes of the "cat," or the six-stranded whip, across the naked back was considered standard punishment for any offense.

When they finished his beating, he was never the same. He was meek, and his

Sing Sing Prison.

Sing Sing Prison in New York. *Courtesy of the Historical Collections of the State of New York.*

Monroe's grave is in the potters' field at Sing Sing.

EDWARDS' GRAVE IN THE POTTERS' FIELD.

face was disfigured. He never tried to trick another person again. Kitty and her son never visited him. He spent his final moments of clarity attempting to convince someone to help him and his mother.

In all his swindles, he made recompense only once. He repaid Lord Spencer.

On a cold day in January 1847, after a long and agonizing death, the Napoleon of forgers was buried in an unmarked grave in the prison cemetery.

"FULL MANY A TEAR AND MANY A SIGH"

Full many a tear and many a sigh,
We shed, alas! for those who die,
Snatched from us by some cruel doom,
E're youth had ripened into bloom.

And wherefore should we bid them stay,
to linger on a weary way,
Through the false world, where power and glory
Are shadows vain and transitory?

Nature her brightest beams hath made
Soonest to be o'ercast with shade;
Her sweetest fragrance, too, is given,
But to be exhaled and borne to heaven.

Better by far their guilt sleep,
Thank like me, to wake and weep,
As on our pilgrimage we go
In sorrow through this world of woe.

—Monroe Edwards, circa 1941
New York, Tombs

EPILOGUE

The Texas region where Monroe earned his title as anti-hero benefited from the economic and rebellious spirit that marked his contemporaries and family. In the years after his death, Texas became a sovereign nation. Then it became a member of the United States and supported the South in the Civil War. In the years after that, the state grew.

Texas grew to prominence as an economic engine when oil was discovered, and it maintains that prominence today. When air conditioning began to take root in the southern regions, the North found the hot Texas heat more bearable. The northern migration that began in the 1960s has had lulls since, but it never really stopped.

Between oil and air conditioning, Texas was able to build on the legends of Monroe's friends and colleagues. Austin's idea that Texas could rival the United States continues to be a touchstone for many Texans, who believe in the "Texas state of mind." The term, coined in the 1920s, remains an undisputed description for the residents who believe in bigger, better and richer as a matter of state pride.

Chenango Plantation grew into a small town in the mid-1900s. A post office, schoolhouse and a few other buildings eventually disappeared over the years, although some maps still show the town of Chenango on them.

Brazoria residents recalled that the sugar mill remained on the property until the millennium. All the other structures were destroyed. Now, developers are building large estate lots on the property.

Epilogue

In San Leon, the Edwards property remains a large swath of underdeveloped territory in Galveston County. Spotted mainly with marine industry, it has hidden treasures that only the locals know. A few locally owned Galveston restaurants that offer fresh Gulf seafood are found at Redfish Bar, where Monroe's family homestead was located.

Edwards Point remains an actual destination in Texas City, where an upscale deep-water residential development has taken root since 2007. Situated in a remote spot on a Gulf access point that bears his father's nickname, Moses Lake features boat access right at a homeowner's front door.

The Nashville Grant that turned into Robertson's Colony has become a tourist and lifestyle destination point for Texans. The Hill Country features upscale neighborhoods that surround the state's capitol. While the legal wrangling between Austin and Robertson delayed Central Texas's growth for years, it became a distinct and popular calling card for the state.

Galveston Island became entrenched in Texas history with Brazoria. The history of Lafitte is a popular tourism marketing tool, although Monroe's pirating is not mentioned. The region that was once known as the territory where one could find Monroe's escaped slaves became the birthplace of Texas. After Monroe's departure, Morgan became the commander of the island during the Texas Revolution. Morgan's homestead is now one of the most important and wealthy locations along the Houston Ship Channel.

Together, these counties have grown into one of the nation's fastest-growing regions, according to 2010 U.S. census data and demographic data. The area is scattered with monuments, statues, museums and landmarks to commemorate the disturbances and battles that created the foundation for the state. Monroe's uncles are remembered as controversial heroes for the Fredonian Rebellion. Slavers such as Jim Bowie are commemorated as legends. Texas students learn about them in history classes around the state.

They do not learn about Monroe Edwards.

BIBLIOGRAPHY

ARTICLES, LETTERS AND PERIODICALS

Barber, Alan. "Schooner *Flash*, Captain Falwell: The Short Wartime Life of a Texian Sailing Vessel, 1835–1837." *East Texas Historical Journal* 47, no. 1 (2009). http://scholarworks.sfasu.edu/ethj/vol47/iss1/7.

Barker, Eugene C. "The African Slave Trade in Texas." *Quarterly of the Texas State Historical Association* 6, no. 2 (October 1902): 145–58. http://www.jstor.org/stable/27784929 Accessed: 19-03-2016 21:41 UTC.

———, ed. *Annual Report of the American Historical Association for the Year 1922: In Two Volumes and a Supplemental Volume*. Vol. 2. University of North Texas Libraries, Portal to Texas History, Denton, TX.

Denham, James. "The Peerless Wind Cloud: Thomas Jefferson Green and the Tallahassee Land Company." *East Texas Historical Journal* (October 1991): 3–14.

Harris, Dilue. "Reminiscences of Dilue Rose Harris." *Quarterly of the Texas State Historical Association* (January 1901): 85–127.

Luskey, Brian P. "Chasing Capital in Hard Times: Monroe Edwards, Slavery, and Sovereignty in the Panicked Atlantic." *Early American Studies* 14, no. 1 (2016): 82.

Rowe, Edna. "The Disturbances at Anahuac in 1832." *Quarterly of the Texas State Historical Association* 6 (April 1903).

Smith, James. "Life on the Brazos: Chenango Plantation." *Brazosport Archeological Society* (2006). http://lifeonthebrazosriver.com/Chenango Plantation.htm.

Strother, Henry. "Honorable John Edwards and John Edwards, Gentleman, First Two John Edwardses in Bourbon Co., KY." *Register of Kentucky State Historical Society* 17, no. 49 (January 1919): 47, 49–52.

Texas State Historical Association. *Southwestern Historical Quarterly* 17 (July 1913–April 1914); 43 (July 1939–April 1940). University of North Texas Libraries, Portal to Texas History, Austin, TX. http://texashistory.unt.edu/ark:/67531/metapth101111.

Thiesen, William H., to Michael Bailey. "Fly Captain." March 22, 2016. United States Coast Guard, Portsmouth, VA.

ARCHIVES

Edwards, Monroe, to Robert M. Williamson. May 1832. Mirabeau B. Lamar Papers #111. Archives and Information Services Division. Texas State Library and Archives Commission, Austin, TX.

Frye, Octavia. "Monroe Edwards." Circa 1900. Rosenberg Library, Galveston, TX.

Morgan, James, to Monroe Edwards. June 1838. Rosenberg Public Library Archives, Galveston, TX.

BOOKS

Argyll, John Douglas Sutherland Campbell, Duke of. *VRI: Queen Victoria, Her Life and Empire.* New York: Harper & Bros., 1901.

Baker, DeWitt Clinton. *A Scrapbook of Texas, Made Up of the History, Biography and Miscellany of Texas and Its People.* New York: A.S. Barnes & Company, 1875.

Barker, Eugene C. *The Life of Stephen F. Austin, Founder of Texas, 1793–1836: A Chapter in the Westward Movement of the Anglo-American People.* Nashville, TN: Cokesbury Press, 1925.

Bernard, Lora-Marie. *Lower Brazos River Canals.* Charleston, SC: Arcadia Publishing, 2014.

Burke, Ruth, and Don Holbrook. *Seabrook.* Charleston, SC: Arcadia Publishing, 2010.

Dyer, J.O. *The Early History of Galveston*. Galveston, TX: Oscar Springer Print, 1916.

Freeman, Frederick. *Africa's Redemption: The Salvation of Our Country*. New York: printed for the author by D. Fanshaw, January 1, 1852.

Gammel, H.P.N. *The Laws of Texas, 1822–1897*. Austin, TX: Gammel Book Company, 1898.

Gray, William Fairfax. *From Virginia to Texas, 1835, Dairy of Col. Wm. F. Gray*. Houston, TX: Gray, Dillate & Co., 1835.

Hertslet, Lewis. *Hertslet's Commercial Treaties: A Complete Collection of the Treaties and Conventions, and Reciprocal Regulations, at Present Subsisting between Great Britain and Foreign Powers*. Vols. 1–31. London: Butterworth, 1840.

Labadie, N.D. "Narrative of the Anahuac, or the Opening Campaign of the Texas Revolution." In *Texas Almanac for 1857*. Galveston, TX: Richardson & Co., 1856.

Leonard, Adrian, and D. Pretel, eds. *The Caribbean and the Atlantic World Economy, Circuits of Trade, Money and Knowledge, 1650–1914*. London: Palgrave Macmillan, 2015.

Luckey, Reverend John. *Life in Sing Sing State Prison, as Seen in Twelve Years' Chaplaincy*. New York: N. Tibbals & Co., 1860.

Murray, John. *Transaction of the Ethnological Society of London*. Vol. 2. London: T. Richards, January 1863.

Order of Managers. *The African Repository and Colonial Journal*. Vol. 14. Washington, D.C.: James C. Dunn, 1838.

Thomas, Hugh. *The Slave Trade: The Story of the Atlantic Slave Trade: 1440–1870*. New York: Simon & Schuster, 1997.

Triplett, Colonel Frank. *History, Romance and Philosophy of Great American Crimes and Criminals*. New York: N.D. Thompson, 1885.

Wharton, Clarence. *The Republic of Texas: A Brief History of Texas from the First American Colonies in 1821 to Annexation in 1846*. Houston, TX: C.C. Young Printing Company, 1922.

Wilkes, George, attrib. *Life and Adventures of the Accomplished Forger and Swindler Colonel Monroe Edwards*. New York: H. Long & Brother, 1848.

Yoakum, Henderson K. *History of Texas, from Its First Settlement in 1685 to Its Annexation to the United States in 1846*. Vol. 1. New York: Redfield, 1855.

BIBLIOGRAPHY

FILM

Secrets of the Manor House: Secrets of Althorp—The Spencers. Pioneer Productions. PBS, 2013.

HISTORICAL MARKER

Hopewell Museum. "John Edwards, 1748–1837." ExploreKYHistory. http://explorekyhistory.ky.gov/items/show/439.

NEWSPAPERS

Cincinnati Enquirer. "Vaux in the Role of Detective." October 1841.

Edwards, Monroe. "Literary Effusions of Col. Monroe Edwards." *New York Herald*, October 30, 1832.

New York Daily Tribune. "Trial of Monroe Edwards." June 11, 1842.

SYMPOSIUM PAPER

Gonzalez, Jorge Felipe. "The Amistad Rebellion Reconsidered in an American Context." Proceedings of Rising Up Hale Woodruff's Murals at Talladega College: A Symposium. New York University Kimmel Center for University Life, New York.

INDEX

Index

ABOUT THE AUTHOR

L ora-Marie Bernard is a Texas author who writes nonfiction stories about the state's resources and historical figures.

When she was a child, her father moved the family from her birthplace in Pennsylvania to Texas. They settled around Fort Worth when the northern steel industry was collapsing. Her father told her Texas was going to be one of the most prosperous states in the nation for the rest of her life. She believed him. Educated and indoctrinated into the "Texas state of mind," she took the state's history for granted as a girl.

As an adult, she worked for the *Fort Worth Star-Telegram*, a Pulitzer Prize–winning newspaper that heralded itself as "Where the West Begins." From there, she moved to Houston/Galveston, where she lived on the island. It was along the state's coastal prairies that she became an award-winning crime, public affairs and investigative journalist. In the birthplace of Texas, she developed a desire to tell historical stories through a modern lens.

She lives in the NASA community of Clear Lake City in Houston.